IMAGES
of America

CLEVELAND'S
DOWNTOWN ARCHITECTURE

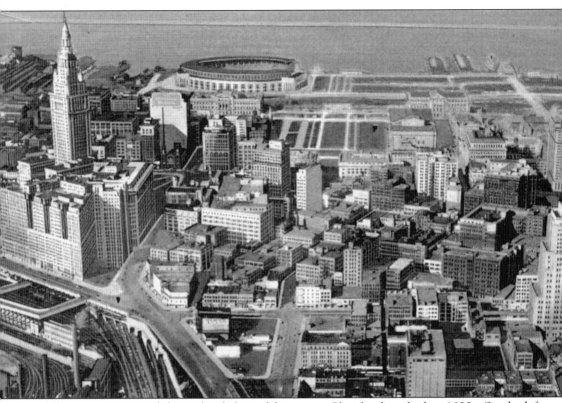

This vintage postcard shows the skyline of downtown Cleveland, c. the late 1920s. On the left side is the Terminal Tower, which dominated the city skyline for more than five decades after completion. Another notable structure in this image is the Municipal Stadium (top center), which was replaced with a modern structure in the late 1990s. The foreground of the image (lower right) is the location of the Gateway sports facilities—Jacobs Field and Gund Arena.

IMAGES
of America

CLEVELAND'S
DOWNTOWN ARCHITECTURE

Shawn Patrick Hoefler

ARCADIA

Copyright © 2003 by Shawn Patrick Hoefler
ISBN 978-0-7385-3202-8

Published by Arcadia Publishing
Charleston SC, Chicago IL, Portsmouth NH, San Francisco CA

Printed in the United States of America

Library of Congress Catalog Card Number: 2003112062

For all general information contact Arcadia Publishing at:
Telephone 843-853-2070
Fax 843-853-0044
E-mail sales@arcadiapublishing.com
For customer service and orders:
Toll-Free 1-888-313-2665

Visit us on the Internet at www.arcadiapublishing.com

CONTENTS

ACKNOWLEDGMENTS

I must first and foremost thank my partner Jason, my family, and my friends for their support.

Many images in this book would not have been possible without the generosity of those who provided location access—Paul Heney, Will Schuck, KeyBank, General Services Administration, Hyatt Hotels, and the R.E. Jacobs Group.

I would also like to thank the staff of the Cleveland Public Library for their generous assistance with researching the publicly available information in their vast collection. The staff's knowledge of available information helped immensely in the research process. Much of the information including construction data, building dimensions, and dates is available through the Sanborn Fire Insurance Maps. I would also like to express very special thanks to the publisher and editor for their exceptional patience.

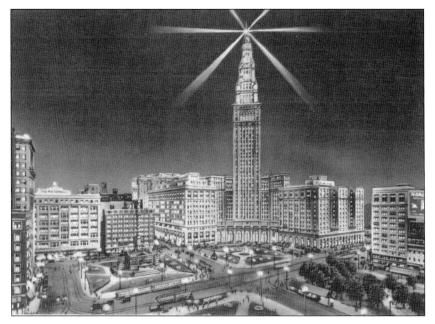

This early view of the Terminal Tower shows the building's dominance of the downtown area as well as Public Square. The buildings on the left of the image were demolished to make way for the BP Tower.

INTRODUCTION

The information and images found in this book were compiled to provide a broad synopsis of the architecture found in downtown Cleveland, Ohio. This book is not intended to be an exhaustive text. My main goal was to highlight the many interesting architectural works in downtown Cleveland, past and present. In order to properly represent the many buildings, I have included vintage postcard images along with my own photography.

There are several other outstanding books that focus on in-depth technical and historical information. As a resident of the city, I've learned to appreciate everything from the well-known buildings such as the Arcade and Terminal Tower, to hidden "gems" such as the Bertsch Building in the Warehouse District. It was a pleasant albeit bittersweet surprise to learn that it was necessary to omit some structures due to space constraints.

Many of the images are of a historic nature, fitting to Cleveland's role as a major industrial and commerce center in the late 1800s and early 1900s. Unfortunately, not all of Cleveland's architectural heritage has been preserved. One of the most regrettable casualties was the decline of Euclid Avenue, once known as one of America's finest residential streets. Even with the loss of most of the famed Euclid Avenue mansions, many Cleveland buildings are finding new use and being restored to their former glory.

Modern buildings are included as well, as they help to illustrate the changing downtown skyline and streetscapes. At one point, it was inconceivable that the Terminal Tower would ever be approached, much less surpassed, in height. At some point in time, these newer structures will be considered historic and to omit them from the book would be a disservice to a city with such a varied collection of notable structures. Some buildings are included that may not be aesthetically pleasing to everyone, but they still comprise important parts of the downtown area.

Areas in the central business district have been given their own section, due to the concentration and similarity of the respective buildings. Other structures may be grouped according to their use or other attribute. Some notable pieces of public art have been included as well for their contribution to the streetscape of downtown Cleveland.

I hope you enjoy reading this book as much as I enjoyed compiling it.

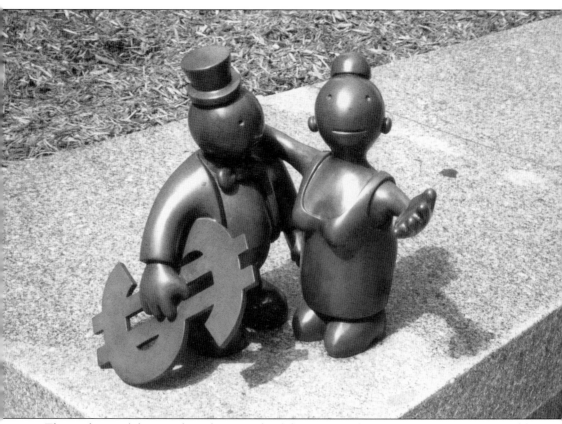

These whimsical figures adorn the grounds of the Louis Stokes Wing of the Cleveland Public Library's main branch. There are several variations of the figures, each representing benefactors, patrons, and the individuals who labored to create the facility.

One

HIGH RISE TOWERS

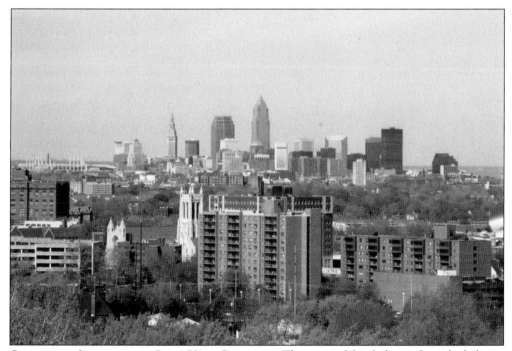

CLEVELAND SKYLINE FROM LAKE VIEW CEMETERY. This view of the skyline is from the balcony of the James A. Garfield monument, located east of downtown in Lake View Cemetery.

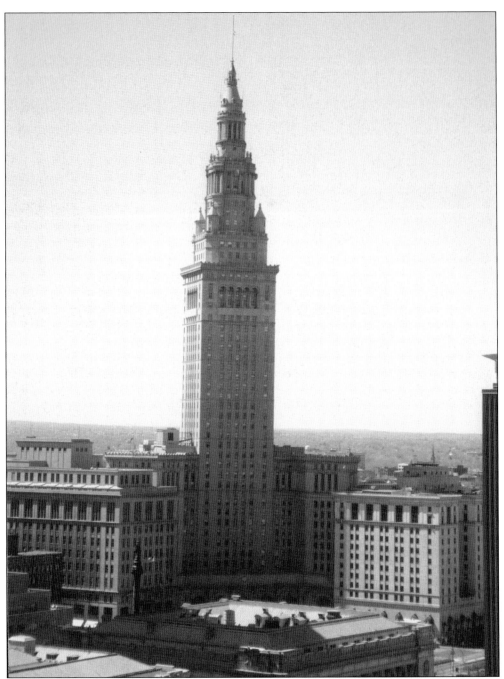

TERMINAL TOWER. The architectural centerpiece of the downtown Cleveland skyline is the 52-story Terminal Tower. This 708-foot structure has remained a symbol of the city ever since its completion in 1930. Designed by the firm Graham, Anderson, Probst and White, it was constructed by Otis and Orin Van Sweringen to provide office space for their Union Terminal project. Due to poor soil conditions underneath downtown Cleveland, the building was constructed on top of massive caissons which reach the bedrock, more than 200 feet below street level.

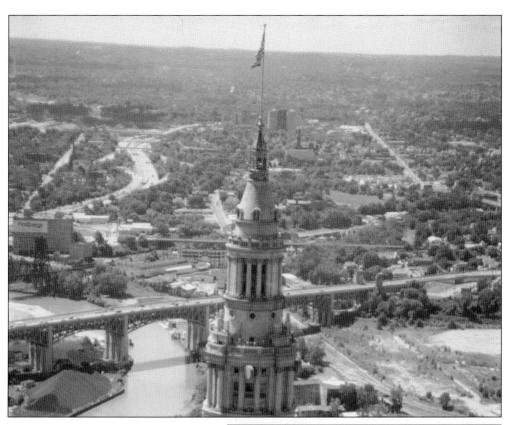

TERMINAL TOWER UPPER FLOOR. The upper section of the Terminal Tower bears a resemblance the Municipal Building in New York City. One notable amenity of the tower is an observation deck on the forty-second floor. Regretfully, the deck has been closed to the public since September 11th, 2001 due to security concerns arising from the atrocities of that day. Thus, Clevelanders have been deprived of some of the best views of not only downtown but the entire city and Lake Erie.

TERMINAL TOWER. The 708-foot tall tower (height not including the 70-foot tall flagpole) was the tallest in the world outside of New York City for several decades. In the mid-1950s, the Lomonosov University tower was constructed in Moscow, Russia and surpassed the Terminal Tower.

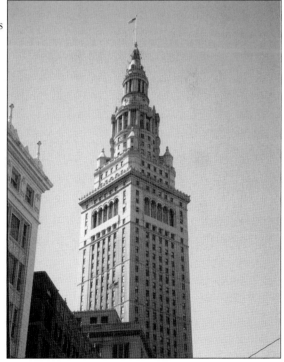

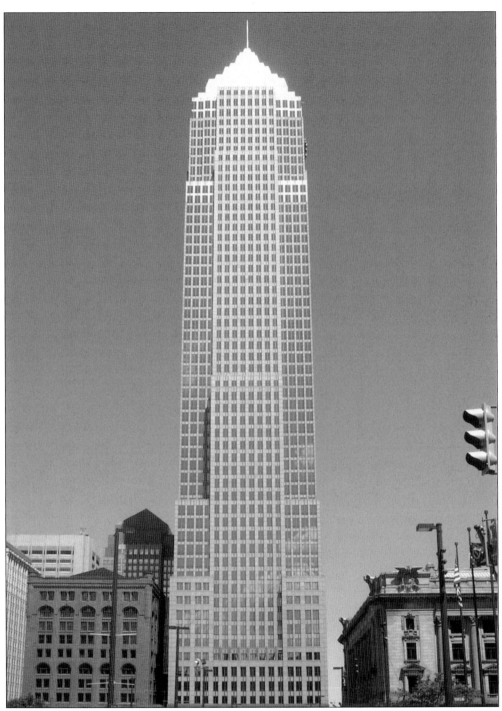

KEY TOWER. Built in 1991 as Society Center, this skyscraper located at 127 Public Square is the tallest in Cleveland as well as the tallest in the state of Ohio. The building was renamed Key Tower when a merger occurred between Cleveland-based Society Bank and Albany, New York-based KeyCorp. Measuring 948 feet to the top, with 57 office floors, this building's crown is visible as far away as 20 miles from downtown Cleveland.

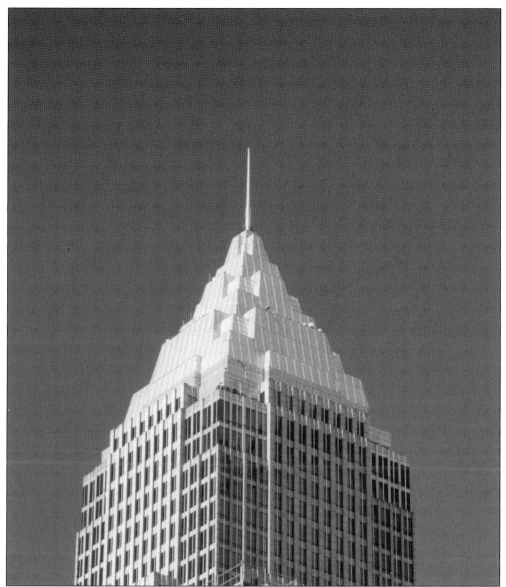

KEY TOWER CROWN. Key Tower was designed by Cesar Pelli and Associates, a firm responsible for many of the buildings in the Cleveland Clinic medical complex. The distinctive pyramidal crown is composed of stainless steel, as are the window mullions rising vertically along the tower's exterior. The spire atop the crown measures 60 feet in height.

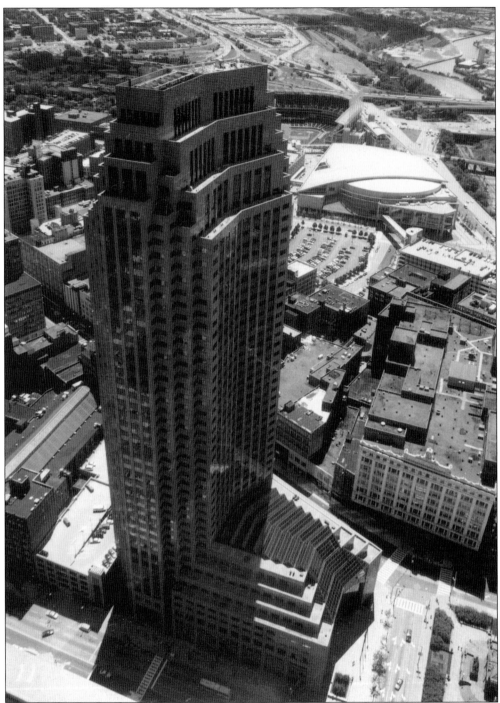

BP TOWER. The third tallest building in the city is this 45-story tower measuring 658 feet in height. The distinctive setbacks on the building's upper profile serve to lessen the massive structure's visual impact on the skyline. Originally constructed as the Standard Oil of Ohio (SOHIO) building, this was renamed the BP Tower when British Petroleum established their North American headquarters in the tower.

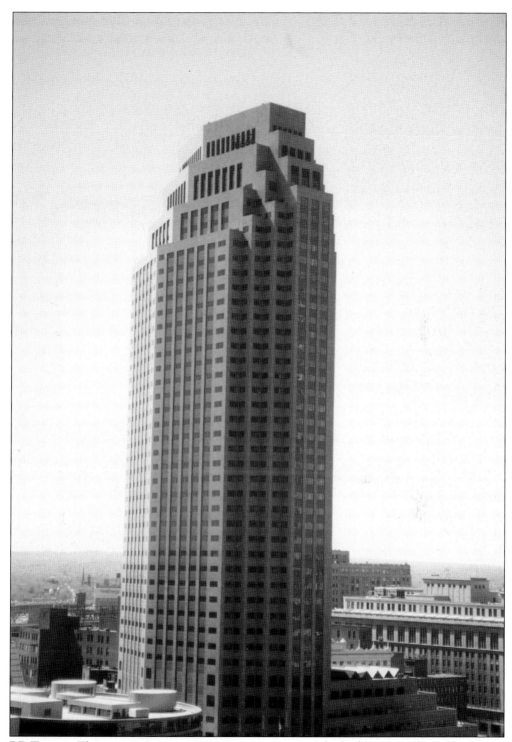

BP TOWER. This tower's 8-story atrium serves to integrate the building into the Public Square streetscape. Another notable feature of the building is the fact that the northern and southern facades are perpendicular to their respective streetscapes due to the angular site plan.

15

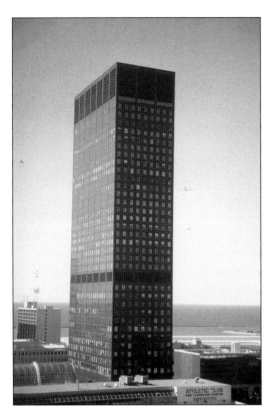

TOWER AT ERIEVIEW. Constructed in 1964, this 529-foot tower was the first major high-rise to be built in the central business district since the completion of the Terminal Tower. The structure was the main landmark of the controversial Erieview urban renewal plan designed by I.M. Pei. What was once a large public plaza west of the tower is now home to the Galleria shopping center (*see Interiors*). A notable amenity of the tower for many years was a restaurant on one of the uppermost floors offering sweeping views of the downtown skyline and Lake Erie.

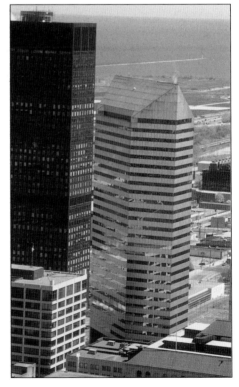

ONE CLEVELAND CENTER. One Cleveland Center's unique six-sided shape and aluminum and glass façade give it a striking appearance in the downtown Cleveland skyline. The tower is of the post-modern style and was constructed in 1983. Stubbins Associates, the firm that designed the Citicorp Center in New York City also designed One Cleveland Center. Unlike many high-rise buildings along East Ninth Street, this structure's main entrance is not aligned with the street grid.

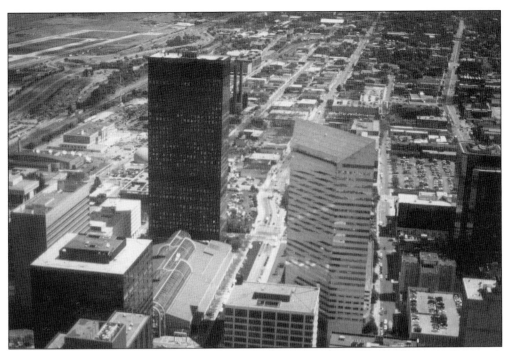

East Ninth–Aerial View. This view from Key Tower shows the 40-story Tower at Erieview's boxy aesthetics and One Cleveland Center's deviation from the street grid.

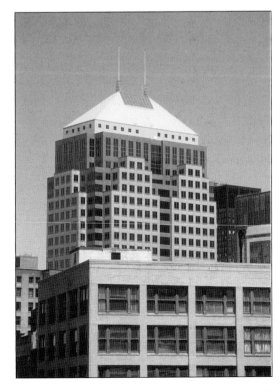

Fifth Third Center. This building at East Sixth Street and Superior Avenue is notable for its distinctive hipped roof and twin spires. The tower was built as the Bank One Center in 1991 and designed by RTKL Associates. This post-modern tower was built on the site formerly occupied by two incarnations of the Hollenden Hotel. At the time of this publication, Cincinnati-based Fifth Third Bank was slated to become the building's major tenant, and the tower to be renamed Fifth Third Center.

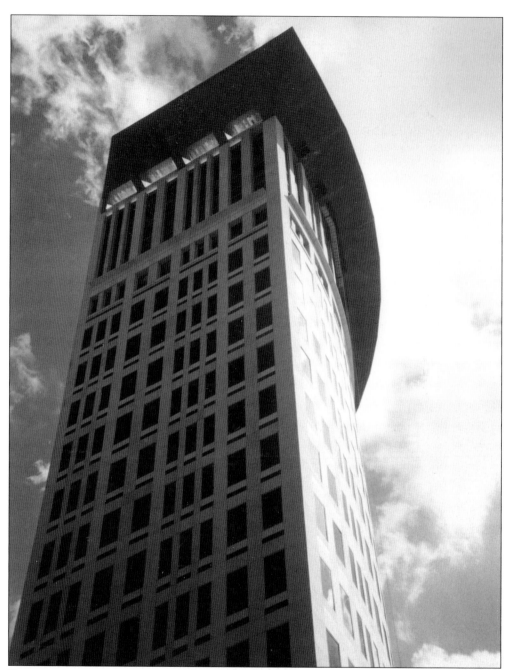

FEDERAL COURTHOUSE TOWER. The newest high-rise tower in downtown Cleveland is the 24-story Louis Stokes Federal Court House Tower. This building lies at the southwestern edge of the central business district near the base of the Veterans Memorial (Detroit-Superior) Bridge. The tower's unique curved façade and bold cornices (one at the building's crown, one on the eastern face near the seventh floor) create a distinctive presence on the skyline. A sculpture representing justice is to be placed at the building's entrance on Superior Avenue. The building is notable for its technological capabilities as well as the fact that it was the first major high-rise in Cleveland to utilize the metric system in its design.

FEDERAL COURT HOUSE AERIAL. This aerial view from Key Tower shows the Federal Court House tower's commanding location on the western end of the central business district. Appropriately, the building's western façade is curved, much like the forms of the nearby Cuyahoga River and Detroit-Superior Bridge.

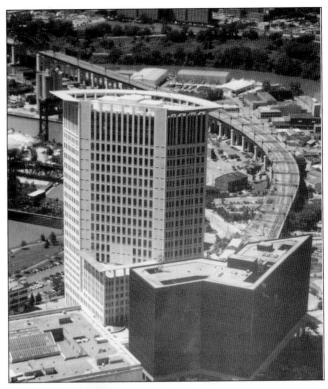

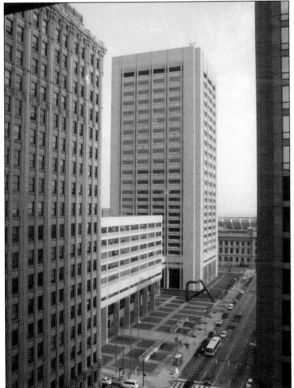

CUYAHOGA COUNTY JUSTICE CENTER/COURTS TOWER. The courts tower of the Cuyahoga County Justice Center contains facilities used by the legal entities and safety forces of Cuyahoga County. The granite-clad 426-foot tower, completed in 1976, features notable public sculptures by famed artists Isamu Noguchi and George Segal.

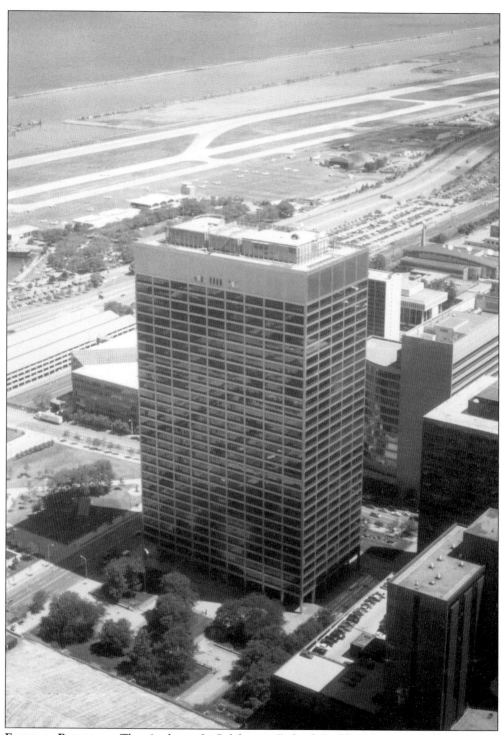

FEDERAL BUILDING. The Anthony J. Celebreeze Federal Building was originally designed as a large 8-story structure with an interior courtyard. The tower stands 419 feet tall with a substantial setback from the street, typical of federal government structures.

NATIONAL CITY CENTER. National City Center stands as an anchor to Cleveland's financial district at the prominent intersection of Euclid Avenue and East Ninth Street. The 410-foot tall tower was completed in 1980 and is home to the National City Corporation. At night the structure is fully illuminated in white light. A below grade plaza is located on the tower's north side, which functions as an outdoor patio for the building's lower floor restaurant. The tower's southern side features a large plaza with an intriguing sculpture by George Rickey.

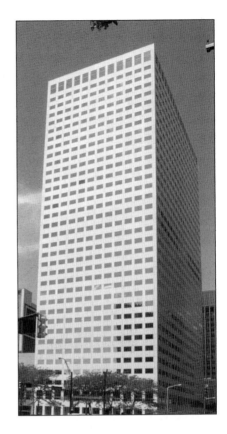

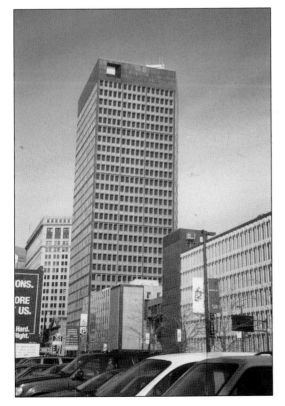

AT TOWER. Built as the Ameritrust Tower, this unusual structure utilizes grids of pre-cast concrete forms to create its distinctive textured curtain wall. The tower was built as an addition to the landmark "rotunda" building at Euclid and East Ninth Street. A second tower was originally planned to occupy the Euclid Avenue site east of the rotunda building but was never constructed. The resulting "honeycomb" appearance of the building has received both praise and scorn. Noted Modernist architect Marcel Breuer, who was also responsible for the addition to the Cleveland Museum of Art in 1971, designed the tower.

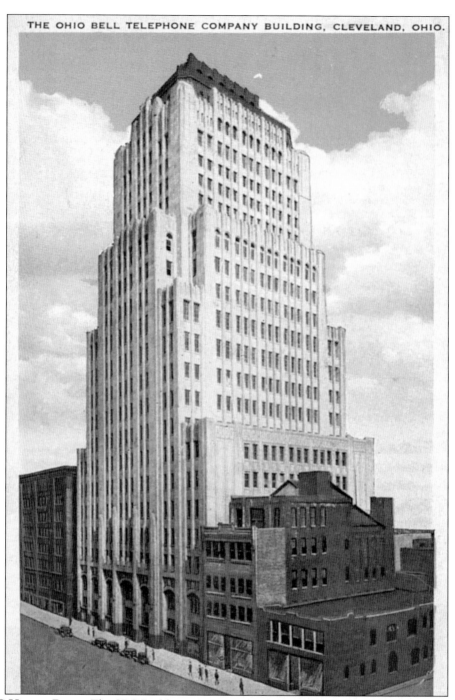

THE OHIO BELL TELEPHONE COMPANY BUILDING, CLEVELAND, OHIO.

SBC HURON ROAD. The SBC Building on Huron Road was originally built as the headquarters for the Ohio Bell telephone company. Constructed in 1927 at 365 feet tall, it was briefly the tallest building in the city of Cleveland until the Terminal Tower was built a few years later. The building's art-deco style is not common in Cleveland high-rise architecture, and was reputedly influential in the appearance of the Daily Planet Building in the Superman comic book series as the creators were natives of Cleveland.

CSU Rhodes Tower. The Rhodes Tower at Cleveland State University serves as a visual anchor in the skyline marking the university's location east of the central business district. At 363 feet, the building soars over the campus and is the tallest academic building in the state of Ohio. Completed in 1971, the tower sits above a low-rise structure and houses the university's library as well as administrative offices. In 2002, illuminated signage was added to the upper section of the building to mark Cleveland State University's role in the downtown skyline.

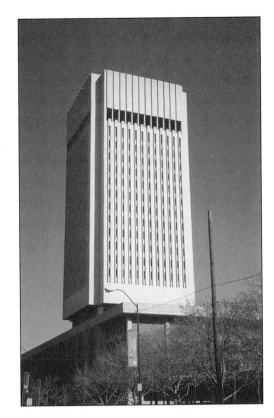

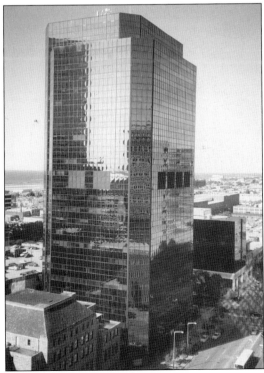

Eaton Center. The Eaton Corporation of Cleveland is headquartered in this 365-foot reflective glass tower at East Twelfth Street and Superior Avenue. Built in 1983, the glassy exterior stands in contrast to the adjacent Cathedral of St. John the Divine. The architectural firm of Skidmore, Owings, and Merrill also designed the National City Center, Penton Media Building, and the Diamond Building in Cleveland.

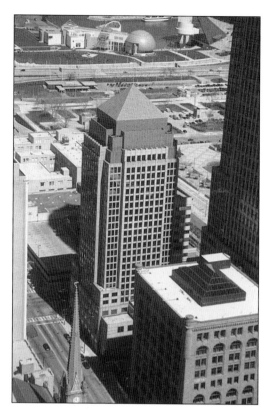

MARRIOTT AT KEY CENTER. The Marriott at Key Center is the tallest hotel in the city of Cleveland, at 320 feet. It shares stylistic elements with Key Tower and is part of the Key Center complex. The 26-story hotel contains approximately 420 rooms. The much-lauded Engineers Building formerly stood on the site and is considered a substantial loss in Cleveland's architectural heritage

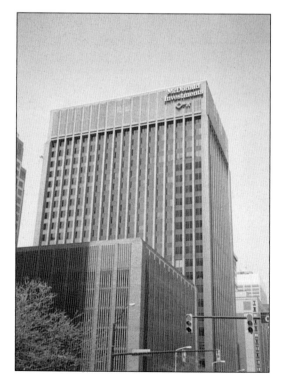

MCDONALD INVESTMENTS CENTER. Built as the headquarters for Central National Bank in 1969, this tower at 800 Superior Avenue, and its adjacent parking garage's brick exteriors, are unusual to downtown Cleveland. Nearly two million bricks were used in the construction of the two structures. The building sits atop a podium that is slightly raised above the streetscape, another unusual feature for downtown Cleveland. Also of note is the small plaza that separates the office tower from the adjacent parking facility.

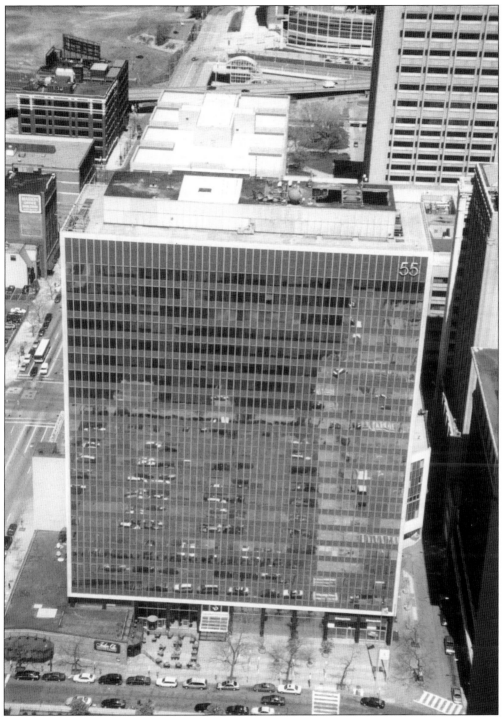

ILLUMINATING BUILDING/55 PUBLIC SQUARE. This 300-foot tower was the first significant building to be constructed on Public Square after the Terminal Tower's construction over two decades earlier. The International Styled-building makes extensive use of glass, which offers a striking reflection of the Terminal Tower.

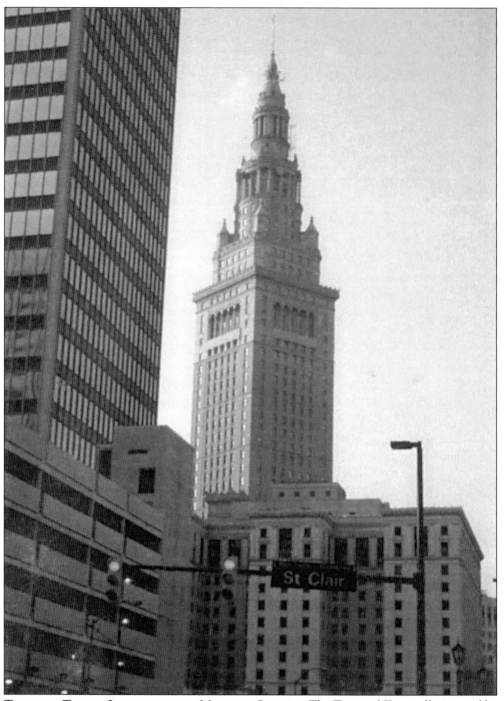

TERMINAL TOWER, ILLUMINATED BY MORNING SUNRISE. The Terminal Tower, illuminated by the morning sunrise, has stood as downtown Cleveland's symbol for over 70 years.

Two

MID-RISE BUILDINGS

SUPERIOR AVENUE STREETSCAPE. The various facades of mid-rise buildings along Superior Avenue comprise one of the city's most handsome streetscapes.

THE HUNTINGTON BUILDING. This massive building was constructed as the Union Commerce Building in 1924 as a result of the merger of nearly two dozen financial institutions. The structure contains one of the world's largest banking halls as well as one the largest offerings of floor space in downtown Cleveland office buildings—no small feat considering the building is only 21 stories in height. The uppermost floor was to serve as a waiting room for travelers awaiting a dirigible; however, it now serves as a restaurant with views of the lake and city.

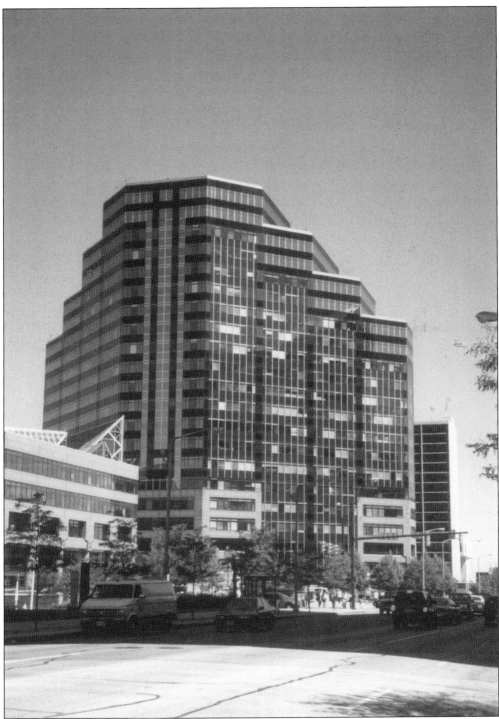

NORTH POINT TOWER. North Point Tower features a signature "stairstep" profile that marks the northernmost boundary of the Ninth Street office tower corridor. Completed in 1991, the 20-story building is sited at the prominent intersection of Lakeside Avenue and East Ninth Street. The tower was designed by a locally based firm, Payto and Associates.

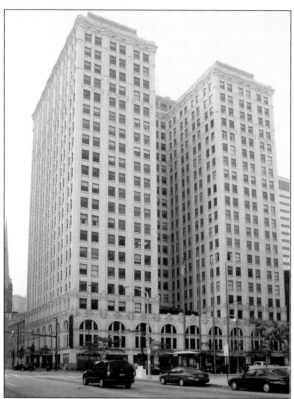

THE STANDARD BUILDING. This 282-foot, 22 story tall structure located at St. Clair Avenue and Ontario Street is exceptionally decorated with terra cotta. The highly stylized geometric motif is also used throughout the building's interior. The southern façade is conspicuously devoid of ornamentation, common to buildings of the era with highly ornamented facades. The architects, Knox and Elliot, also designed Cleveland's Rockefeller Building.

STANDARD BUILDING DETAIL. A close up view of the geometric motif used in the Standard Building's terra cotta cladding.

EAST OHIO BUILDING. This tower, designed by Emery Roth, is typical of the late-1950s construction seen around the United States with extensive use of glass and metal in its curtain wall.

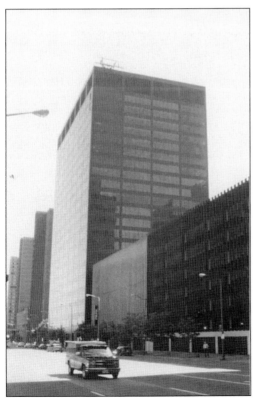

DIAMOND BUILDING. This 21-story tower was built as the Diamond-Shamrock tower for a corporation no longer present in Cleveland.

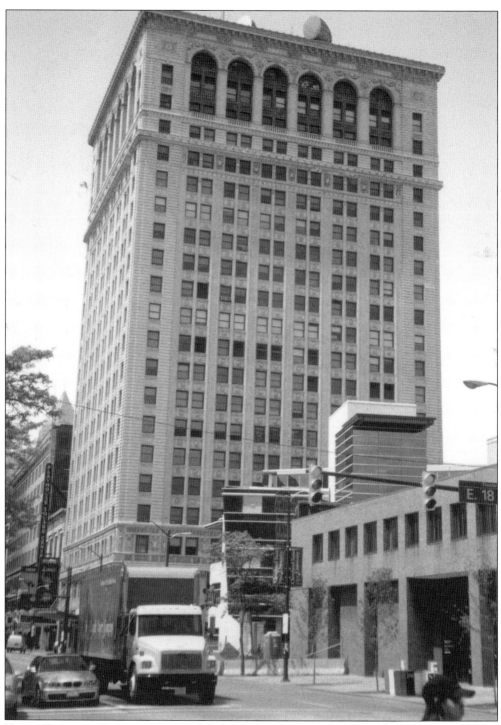

KEITH BUILDING. Soaring above the Playhouse Square district, this building was the tallest in the city at the time of construction in 1922. The tower was designed by the Rapp Brothers, who were also noted for their extensive work designing grand theatres. This tower was designed and named for B.F. Keith, an entrepreneur in the theatre world.

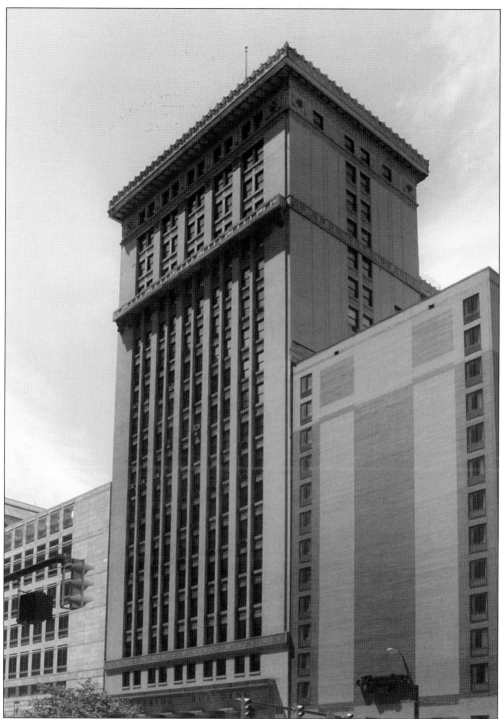

SUPERIOR BUILDING. This tower on Superior Avenue was built as the Cleveland Discount Building, and features a set of imposing Doric columns at its base and a heavily ornamented cornice. Constructed in 1922, this building was designed by the Cleveland-based firm of Walker and Weeks.

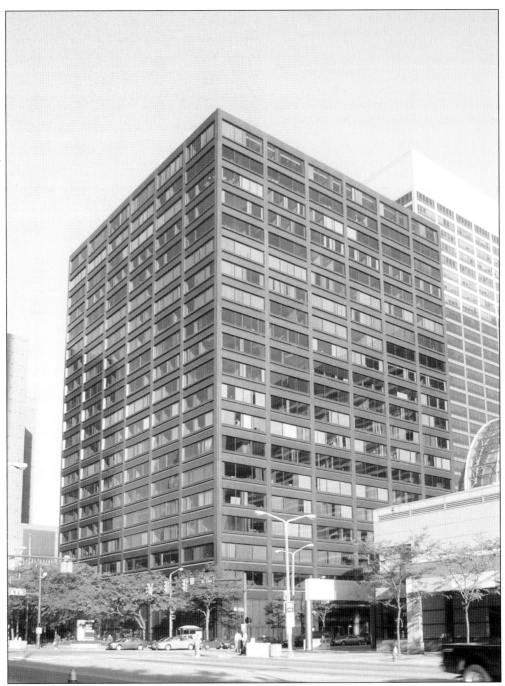

PENTON MEDIA BUILDING. Built as the Bond Court Office Tower in 1970, this 21-story building was designed by Skidmore, Owings and Merrill. It was built atop what was formerly Bond Court, a small street on the site. The office tower was constructed in conjunction with the Bond Court Hotel, now known as the Sheraton City Center.

FENN TOWER. Constructed in 1930 as a social club, this building was acquired by Cleveland State University. It features unusual art-deco sculptural accents at the base and crown. At the time of this publication, the building was being considered for conversion into dormitory space for Cleveland State University students.

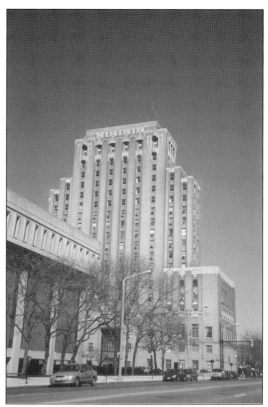

LANDMARK OFFICE TOWERS. This massive structure located between Huron Road, West Second Street and Ontario Avenue was built as part of the Terminal Tower complex, but unlike other buildings in the group, Landmark Office Tower features an art-deco design. The group consists of three connected tower—a fourth was to be built on the southeastern corner of the site but never materialized. The interconnected buildings contain the Van Sweringen Arcade, an interior passage notable for extensive woodwork as well as a similarly styled banking hall.

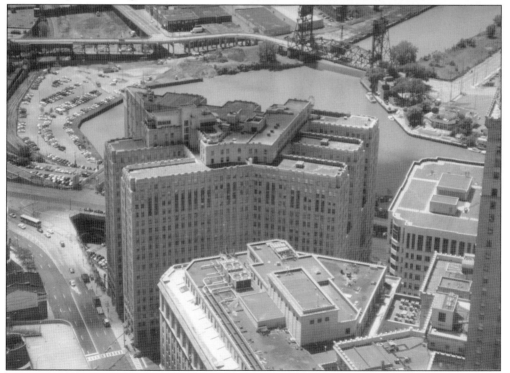

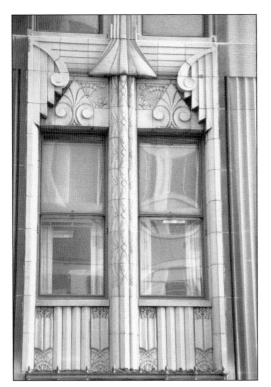

LANDMARK OFFICE TOWERS. This close-up view of the façade shows the intricate art-deco motif prevalent on the building's exterior. The ornamentation is especially prominent on the building's lower floors.

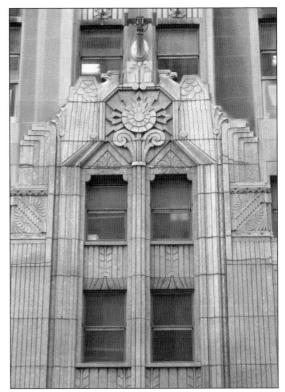

LANDMARK OFFICE TOWERS. This view of the Prospect Avenue façade shows a variety of art-deco motifs displaying influence by Aztec artwork.

SBC LAKESIDE. This post-modern building's southern façade features an unusual window-wall with the windows protruding at an angle. The result is a reflection of adjacent buildings as well as the streetscape below. The northern façade features a massive curved wall of glass.

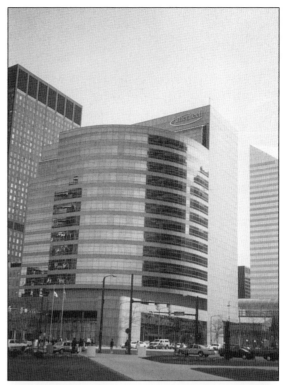

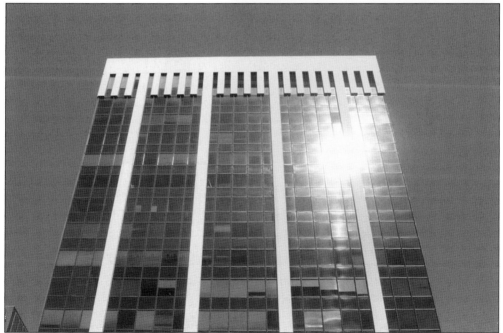

OHIO SAVINGS PLAZA. Constructed in 1975 as Investment Plaza, this building features a covered pedestrian colonnade on its East Ninth Street and Chester Avenue facades. The tower's upper floors are marked with alternating glass and concrete. The tower is connected to a smaller 8-story "twin" via a parking deck.

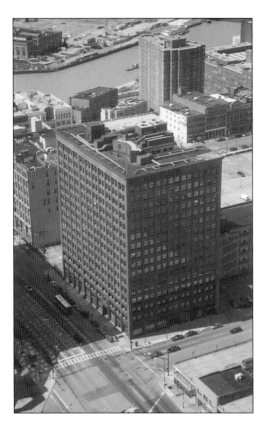

ROCKEFELLER BUILDING. One of the tallest office buildings in the Historic Warehouse District, this 16-story building was built to serve as the Cleveland headquarters for the Standard Oil Company, founded by billionaire John D. Rockefeller. Designed by the firm of Knox and Elliott, the building had four additional window bays constructed on its southern façade several years after its initial completion. The highly decorative cast-iron façade is reflective of buildings designed by Louis Sullivan.

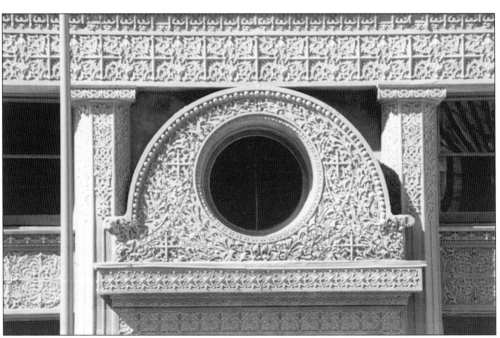

ROCKEFELLER BUILDING DETAIL. This image shows the intricately detailed cast-iron façade along with the notable entryway.

HOLIDAY INN EXPRESS/GUARDIAN BUILDING. The first multi-story steel frame building to be constructed as the Guardian Building on Euclid Avenue, this structure was originally 14 stories high but 2 floors were added at a later date. The building was originally constructed for use as an office tower but was recently converted into hotel use by the Holiday Inn corporation, one of the first adaptive reuse projects in the chain's history.

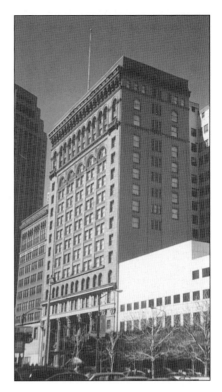

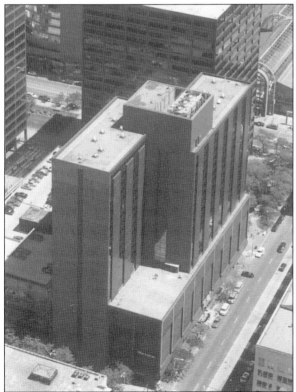

SHERATON CITY CENTER. This hotel was constructed as the Bond Court Hotel along with the Penton Media Building—it suffered a partial collapse during the initial construction but was successfully completed. The building's exterior makes extensive use of brick and reflective glass.

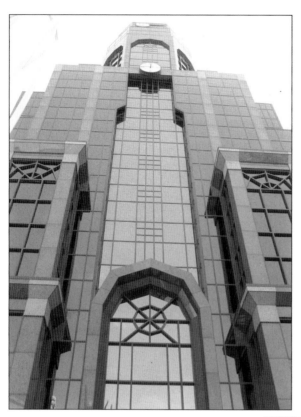

US BANK CENTER. This postmodern mid-rise makes extensive use of reflective glass and was the first major new construction in the Playhouse Square district since before World War II. The building's setbacks, reflective glass, and three turret-like crowns give the structure a unique profile amongst its more classically styled neighbors. The building was renamed US Bank Center after Minneapolis-based US Bank became a major tenant.

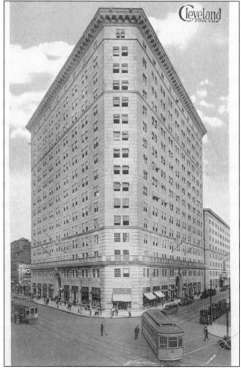

HANNA BUILDING. Home to one of Playhouse Square's five theatres, this 1921-built landmark features extensive neo-classical detailing. Like the nearby Wyndham Hotel, this building has been enhanced with unique lighting features and a large video screen. The building's southern annex houses one of the five famed theatres in Playhouse Square.

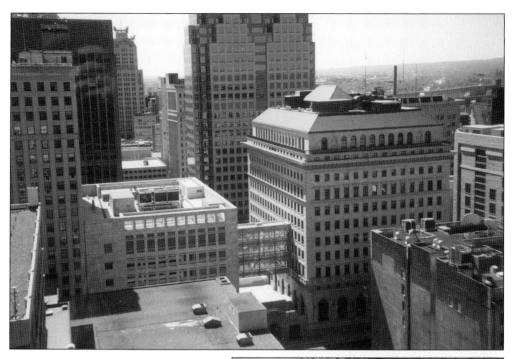

FEDERAL RESERVE BANK OF CLEVELAND. One of downtown Cleveland's most remarkable buildings, this structure was completed in 1924. This is considered one of the most successful buildings designed by Cleveland-based firm Walker and Weeks. The 12-story Renaissance-style building features a banking lobby with gleaming marble flooring as well as striking wrought-iron accents. Also of note is the East Sixth Street entrance, which formerly concealed weaponry for the bank's security forces. In 1992, an addition containing parking facilities, a new cash vault and a glassed skywalk was constructed utilizing similar marble as the original building.

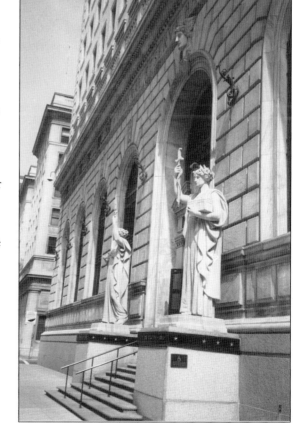

FEDERAL RESERVE/DETAIL. This view shows the East Sixth Street entrance to the facilities with the imposing statuary standing guard.

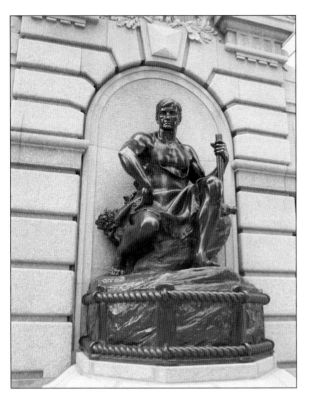

FEDERAL RESERVE/ENERGY.
Located at the Superior Avenue
entrance of the Federal Reserve
Bank of Cleveland, this sculpture
is a landmark on the Superior
Avenue streetscape.

THE CHESTERFIELD. One of the
earliest high-rise residential buildings
in Cleveland, this 1967-built structure
features a rooftop swimming pool
for the residents. The 400-plus unit
building underwent substantial exterior
renovations in 2001.

PARKVIEW APARTMENTS. This tower was built as part of the Allerton Hotel chain that eventually went out of business. The building has served as a residential structure since the hotel closure.

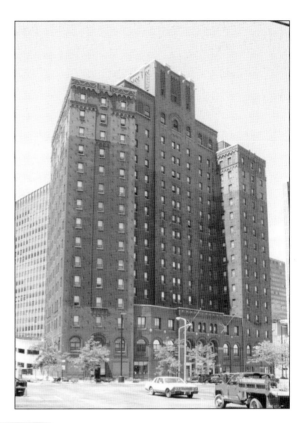

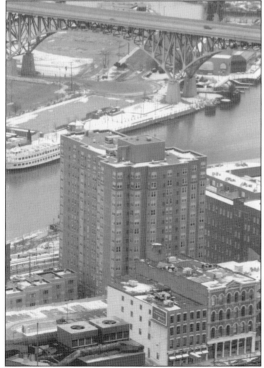

CRITTENDEN COURT APARTMENTS. One of the first residential towers in the Flats, this building was designed by local Cleveland firm, Richard L. Bowen and Associates. The building was named after its construction site, just west of the Crittenden Building located on West Ninth Street.

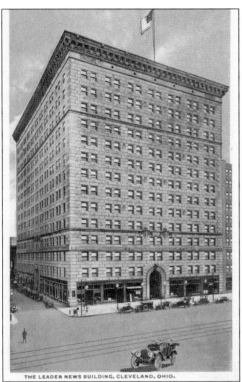

THE LEADER NEWS BUILDING, CLEVELAND, OHIO.

LEADER BUILDING. This building was constructed as the headquarters for the relatively short-lived publication, the *Cleveland Leader*. The handsome structure features a small yet ornate lobby as well as extensive detailing on its upper floors and cornice.

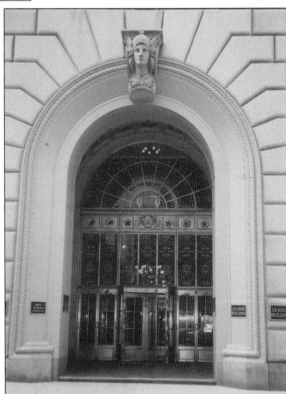

LEADER BUILDING DETAIL. This attractive gargoyle graces the Leader Building's East Sixth Street and Superior Avenue facades.

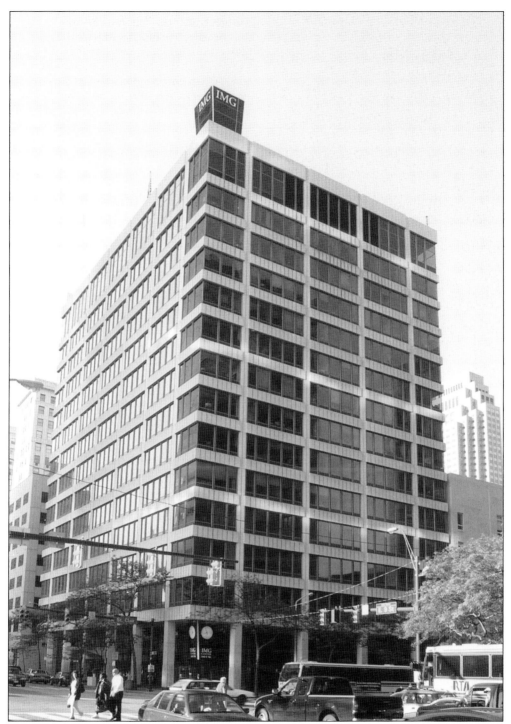

IMG CENTER. Although similar in shape to other office buildings along the East Ninth corridor, this building is distinguished by its use of glass in place of typical corner supports. Built as One Erieview Plaza, the structure was renamed IMG Center after its well known tenant, a sports marketing and PR firm.

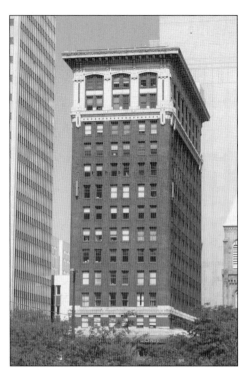

75 PUBLIC SQUARE. This handsome structure was designed by the Cleveland-based firm, Hubbel and Benes and was constructed in 1915. The building's brick exterior and extensively decorated cornice help distinguish it from its taller counterparts on Public Square. Hubbell and Benes designed a substantial number of other Cleveland landmarks including the West Side Market.

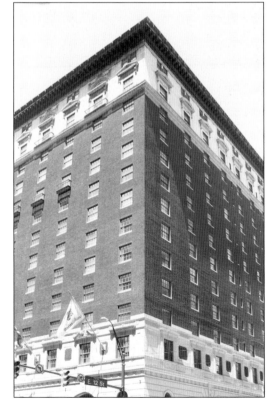

STATLER ARMS. Located at East Twelfth Street and Euclid Avenue, this building was constructed as the Statler Hotel in 1912. Eventually the building was used as office space but in the late 1990s, the structure was converted to residential use.

WYNDHAM HOTEL. Situated at the intersection of Huron Road and Euclid Avenue, this hotel features a cylindrical tower with metallic accents at its crown. As part of the Playhouse Square district's effort to enhance the pedestrian experience, the building had fiber-optic lighting and a large video screen attached to its façade.

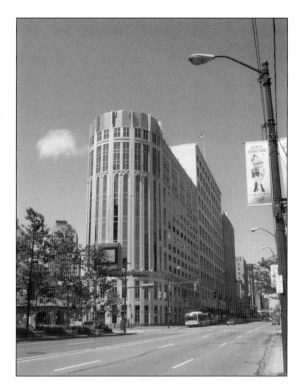

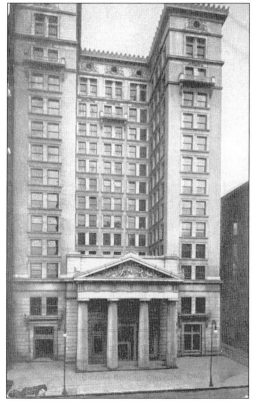

CITY CLUB BUILDING. The entrance of this building originally contained Doric-styled elements—notably a pediment supported by a series of columns, as seen in this vintage postcard. However, the entry was altered substantially to accommodate retail space. The ornamentation on the upper floors remains intact. This building is home to the City Club, one of the oldest forums in the nation for free speech, debate and discourse.

47

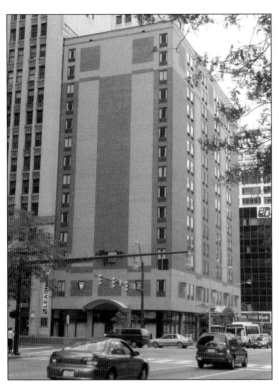

HAMPTON INN. This straightforward hotel at East Ninth Street and Superior Avenue replaced the similarly sized Olmsted Hotel in 1997.

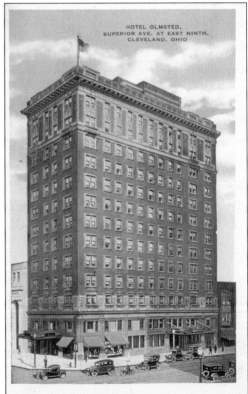

OLMSTED HOTEL. This vintage postcard depicts the Olmsted Hotel, which formerly stood at the site of the current Hampton Inn.

CLEVELAND ATHLETIC CLUB. This building's most notable exterior feature is the Euclid Avenue façade, with a series of windows that change dramatically along with the height of the building. The structure's base and lower floors contain public space in the form of retail and office space, while the upper floors play host to one of Cleveland's oldest private clubs.

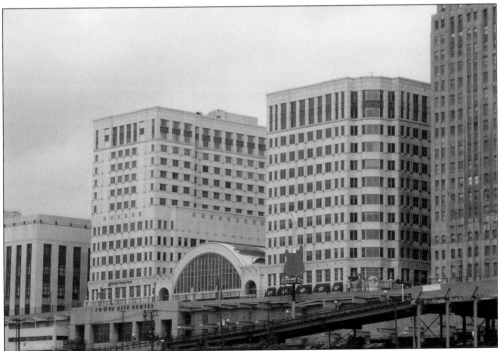

RITZ-CARLTON HOTEL/SKYLIGHT OFFICE TOWER. The two structures in this photo were built in 1990 as part of the Tower City Center project. Although somewhat post-modern, the buildings complement the neo-classical context of the Terminal Tower group in their cladding and scale.

THE HALLE BUILDING. Originally constructed as the Halle Brothers Department Store, this building underwent a conversion to office space in the late 1980s. Many of the original features of the store remain, including a notable fountain in the lobby. The building's façade became well publicized as the fictitious department store portrayed in the Cleveland-based sitcom "The Drew Carey Show."

LAUSCHE STATE OFFICE BUILDING. This black-glass building occupies an irregular site at the intersection of Huron Road and Superior Avenue. The building's northern entrance on Superior Avenue features a striking sculpture by Tony Smith.

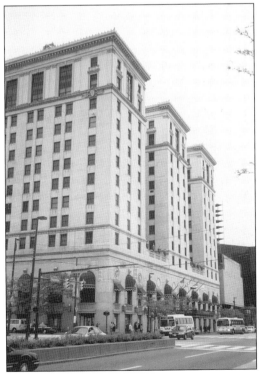

RENAISSANCE HOTEL. Built as the Hotel Cleveland in 1918, this structure is truly a landmark on Public Square. The 500-room hotel features an exquisite fountain in the lobby, as well as being directly connected to the amenities within Tower City Center. The hotel's ballroom is located east of the main structure, a later addition.

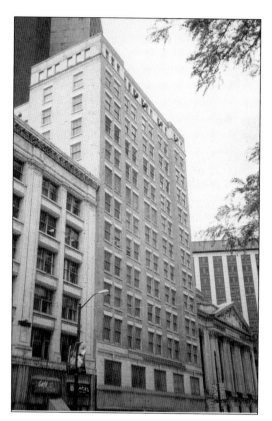

1010 EUCLID AVENUE. This building was at one time scheduled for demolition to make way for a twin of the Marcel Breuer-designed Ameritrust tower located at 900 Euclid. The second tower was never constructed and this building remains.

EUCLID AND NINTH TOWER. This tower's original ornate façade was covered in the mid twentieth century, creating a less than desirable result at the prominent East Ninth Street and Euclid Avenue intersection.

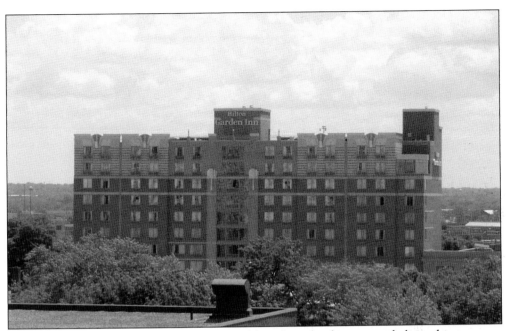

HILTON GARDEN INN. One of the newest additions to the downtown skyline, this structure was designed by Cleveland-based City Architecture. The hotel's conference center incorporates an adjacent industrial structure.

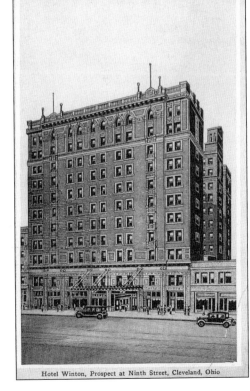

Hotel Winton, Prospect at Ninth Street, Cleveland, Ohio

HOTEL WINTON/CARTER MANOR. This Gateway neighborhood landmark was constructed as the Hotel Winton in 1910. Once a luxury hotel, it now serves as low-income housing, with some of its distinctive ornamentation no longer present.

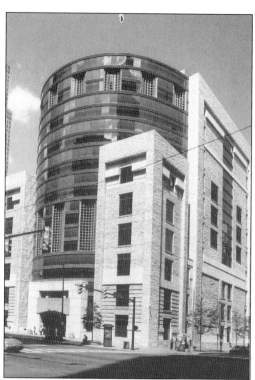

LOUIS STOKES WING/CLEVELAND PUBLIC LIBRARY. This 10-story tower was built on the former site of the Cleveland Plain Dealer building at East Sixth Street and Superior Avenue. Although built in the late 1990s, the structure complements the context of the adjacent Group Plan buildings with use of rugged masonry accents on its four corners. The main tower is comprised of a cylindrical glass tower—a shape not commonly seen in downtown Cleveland buildings.

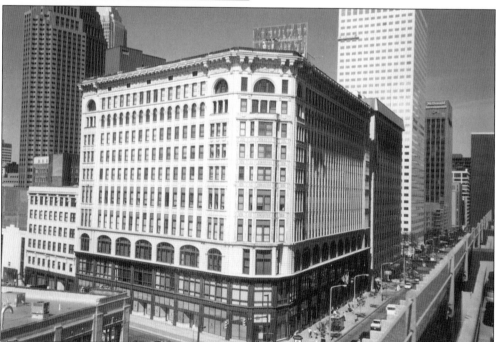

ROSE BUILDING. Headquarters to the Medical Mutual company, this stunning building's most recognizable feature is its exquisite terra-cotta cladding. Located at the prominent intersection of East Ninth Street and Prospect Avenue in the Gateway neighborhood, the 10-story building was constructed in 1900 and designed by George H. Smith.

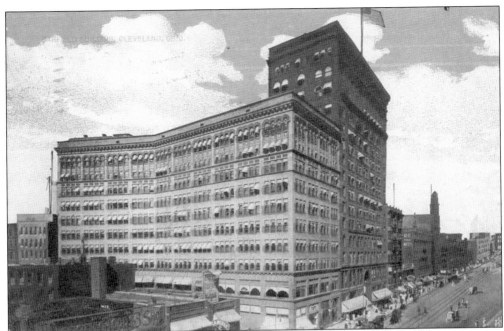

GARFIELD BUILDING. This building occupies a site at the densely packed intersection of East Sixth Street and Euclid Avenue. It now serves as office space for the National City Corporation whose headquarters lie just a short walk to the east. Also visible in this vintage postcard is the clock tower of the former Hickox Building, where the National City Center now stands.

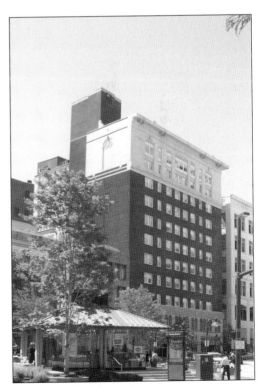

1220 HURON ROAD. Formerly known as Carnegie Hall, this building is faced in red brick, a rarity in the Playhouse Square area.

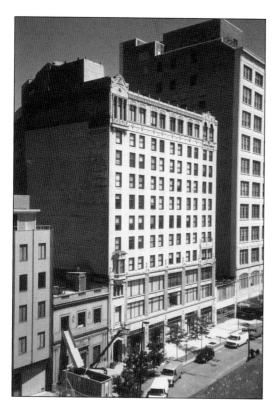

HURON SQUARE APARTMENTS. Located at 1010 Huron Road, this building originally served as office space for many in the medical profession. In the late 1990s, the structure underwent a substantial restoration and conversion into a residential building. The intricately detailed façade facing Huron Road is of note.

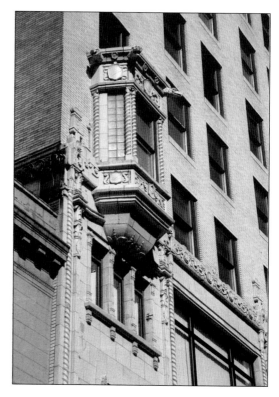

HURON SQUARE DETAIL. The building features this unusual and singular Chicago-style window on its southern façade.

SOCIETY FOR SAVINGS. This building is one of the oldest on Public Square. In 1991, the building was incorporated into the design and construction of Key Tower. The building is the only remaining Public Square office structure designed by the noted firm, Burnham and Root. The other would be the Cuyahoga Building, demolished to make way for the BP America Tower. A light court was filled in with office floors; however, the banking lobby's stained glass ceiling was preserved and is artificially illuminated.

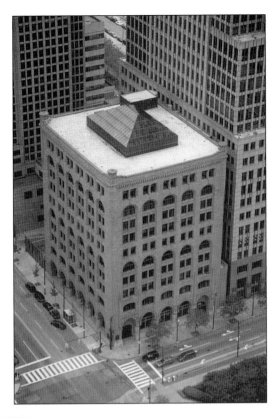

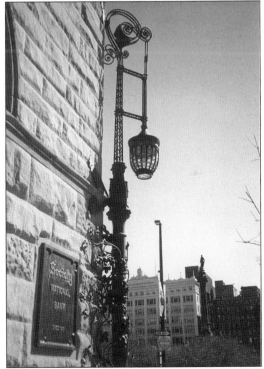

SOCIETY FOR SAVINGS. This building features a decorative lamp on its southwest corner, as well as numerous intricate carvings on its red sandstone façade.

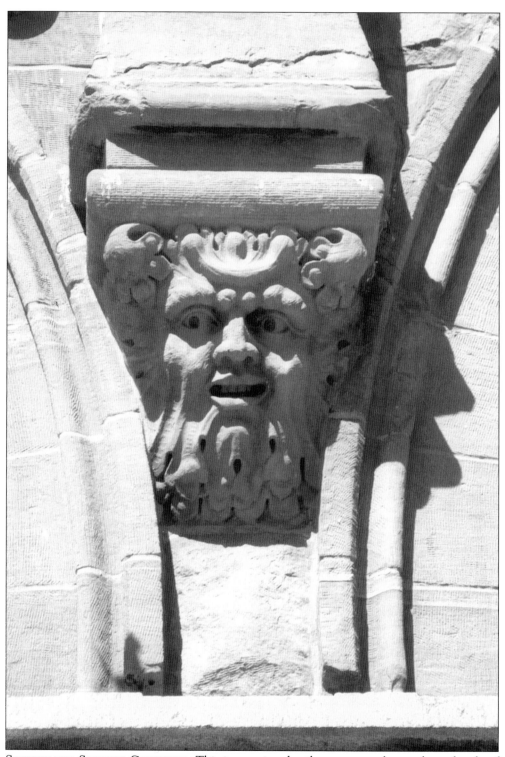

SOCIETY FOR SAVINGS GARGOYLE. This interesting detail appears on the southern façade of the Society for Savings Building along with other notable sculptural elements.

58

Three

LOW RISE BUILDINGS

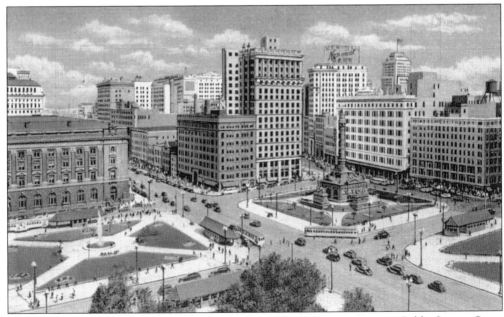

PUBLIC SQUARE. This vintage postcard shows some of the earliest structures on Public Square. Some have been razed to make way for other projects, but some remain intact and well maintained.

CAXTON BUILDING. This Gateway neighborhood landmark was constructed in 1903 to house workers and equipment in the printing industry. The building's southern façade is much more restrained than the extensively detailed Huron Road façade.

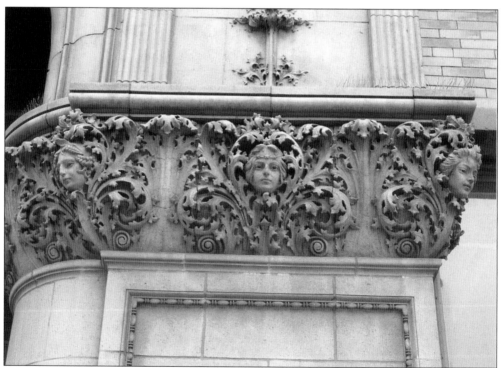

CAXTON BUILDING DETAIL. A detailed view of the intricate terra-cotta work found at the building's Huron Road entrance.

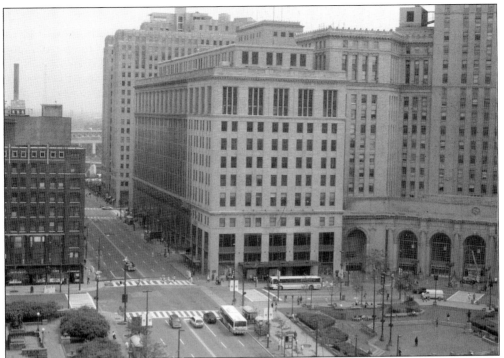

HIGBEE BUILDING. This Public Square landmark has appeared in the holiday classic feature film *A Christmas Story* and was a mainstay of retail in downtown Cleveland for decades. Sadly, the Higbee company was acquired by another retailer in the 1990s, which vacated the Public Square location after a brief and uninspired stint. Of note is the building's Silver Grille restaurant that has been reopened to host private events.

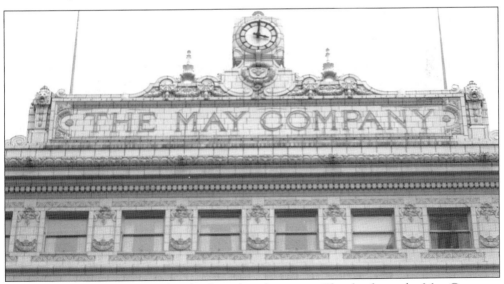

MAY COMPANY. Another landmark of retail in downtown Cleveland was the May Company store, also located on Public Square. The building's notable terra-cotta façade and clock tower have been a commanding presence on Euclid Avenue for several decades. Although no longer home to a retail store, the structure serves as office space on several floors.

SINCERE BUILDING. This eight-story structure at East Fourth Street and Prospect Avenue is undergoing conversion into upscale residential units. The expansive windows will provide tenants with sweeping views of the Gateway neighborhood and the lively East Fourth streetscape.

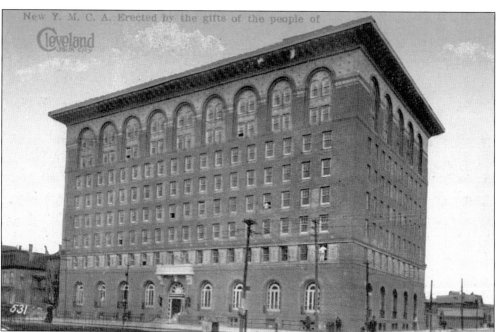

DOWNTOWN YMCA. Located on the eastern edge of the central business district, this building's arched upper-story windows coupled with the large flat cornice create a striking presence on the skyline.

1021 EUCLID AVENUE. This small yet handsome structure features a masonry façade with a decorative cartouche located at the seventh floor.

CHARTER ONE BANK BUILDING. Located at East Twelfth and Superior Avenue, this structure was designed by Cleveland-based architects Richard L. Bowen and Associates. The angular reflective glass façade creates a variety of interesting reflections of the nearby streetscape.

OSBORN BUILDING. This building is located on an irregular site formed by the intersection of Prospect Avenue and Huron Road. The flatiron styled building initially served as offices for the medical profession, including an early incarnation of the city's world-famous Cleveland Clinic. Over the years the building fell into disrepair but was tastefully restored in early 2002 for use as a residential structure.

64

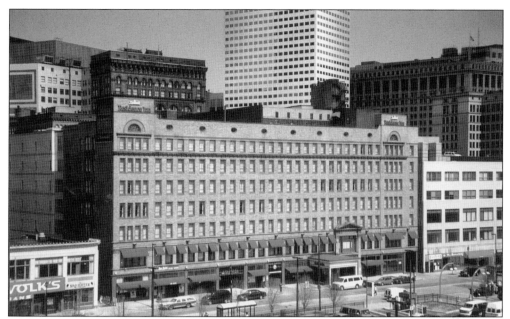

MARRIOTT RESIDENCE INN. This structure located along Prospect Avenue is home to one of the city's largest historic preservation projects. The upper floors are used as extended-term hotel rooms, and the ground-level floor contains the Euclid Arcade and the Colonial Arcade, collectively called the Colonial Marketplace.

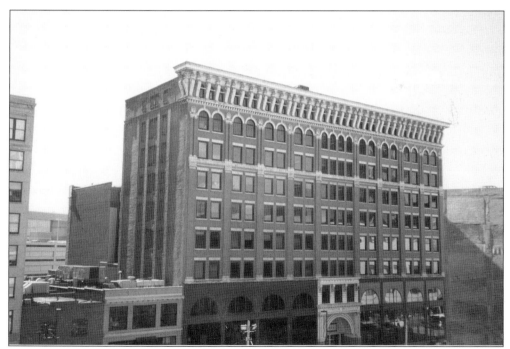

UNITED CHURCH OF CHRIST. Also located on Prospect Avenue, this handsome building is home to the United Church of Christ headquarters. The building's red brick façade and heavily bracketed cornice have a commanding presence on the Prospect Avenue streetscape.

TOWER PRESS BUILDING. Built as the Wooltex Factory, this large building fell into considerable disrepair. After substantial restoration, the building is now home to loft apartments and artists' studios. The development team behind the restoration creatively converted the signature tower structure into a multi-level residential unit.

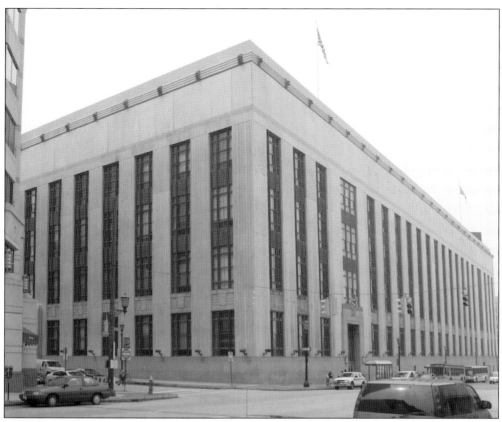

MK FERGUSON PLAZA. This expansive building was the second to be constructed in downtown as a postal service facility. Eventually the postal service relocated and this structure was converted to use as an office building. It features restrained but attractive art-deco detailing throughout.

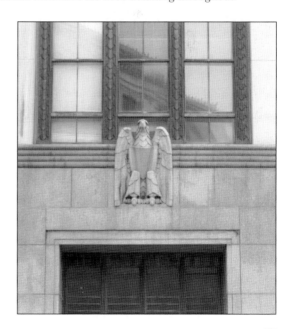

MK FERGUSON PLAZA DETAIL. This stylized eagle serves as a guardian over the Prospect Avenue entrance to MK Ferguson Plaza.

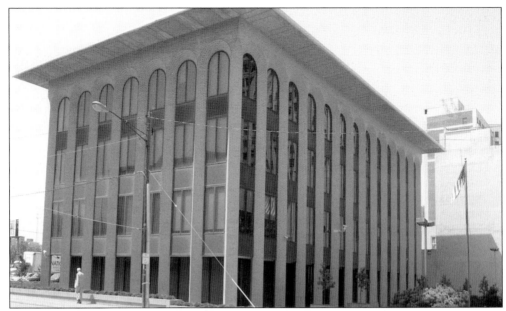

JEWISH COMMUNITY FEDERATION OF CLEVELAND. The flat cornice and arch-topped windows in the thirteen bays facing Euclid Avenue distinguish this building from its surroundings. The building is also set back substantially from the street, creating a small plaza.

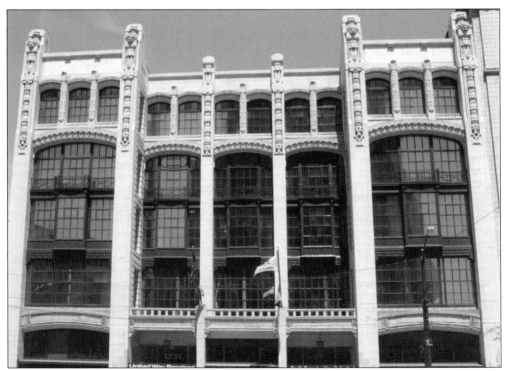

UNITED WAY SERVICES. This small building is a Playhouse Square landmark with its expansive windows and sculptural accents along the roofline. At one time this structure was home to the Bonwit Teller department store.

UNION CLUB. This handsome and imposing structure is home to one of Cleveland's most prestigious private clubs. The dramatic cornice, quoins, and window ornamentation reflect the building's austere purpose.

BUCKEYE BUILDING. Renovated in 1996, this former office building anchors the prominent East Fourth Street and Prospect Avenue intersection in Cleveland's Gateway neighborhood. It now serves as a mixed-use structure with residential units on the upper floors and street level retail space.

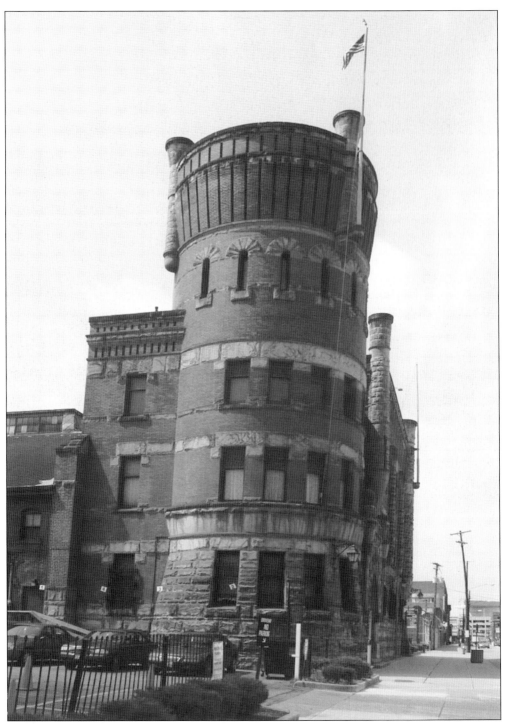

GRAYS ARMORY. One of the landmarks of Cleveland's Gateway neighborhood, this imposing building is home to the Cleveland Grays, a former urban military group, now a philanthropic social organization. The building's heavily reticulated stonework and impressive corner tower add to its prominence along Bolivar Road.

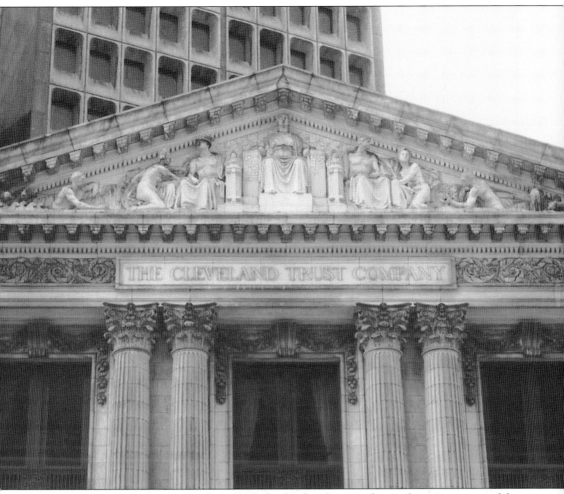

CLEVELAND TRUST BUILDING. Built in 1905, this landmark sits at the southeastern corner of the East Ninth Street and Euclid Avenue intersection. Due to a series of bank mergers, this building was vacated in the mid-1990s, yet is still very well preserved. The pediment on the Euclid façade (seen here) is reflected on the East Ninth façade as well. At the time of publication, the owners of the building were applying for grants to aid in the building's cleanup and restoration.

MAXINE LEVIN GOODMAN COLLEGE OF URBAN AFFAIRS. Located at the southwestern edge of Cleveland State University, this building is home to Cleveland State University's renowned urban studies program. The building stands in great contrast to other buildings on the CSU campus, which are frequently in the Brutalist style. With its interestingly juxtaposed façade of glass and brick, the building holds a commanding presence on the Euclid Avenue corridor.

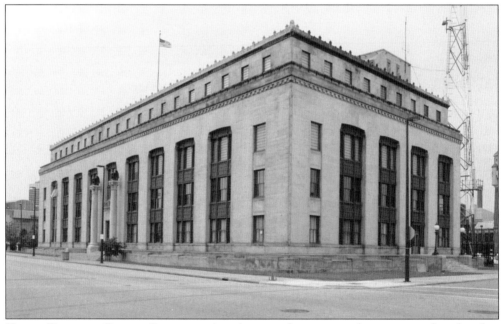

THIRD DISTRICT POLICE STATION. A rather grand structure when compared with other facilities used for safety forces in the city. The entrance of the building is marked by twin columns supporting stylized sculptures of eagles. The building also features scalloped ornamentation around the perimeter of the roof.

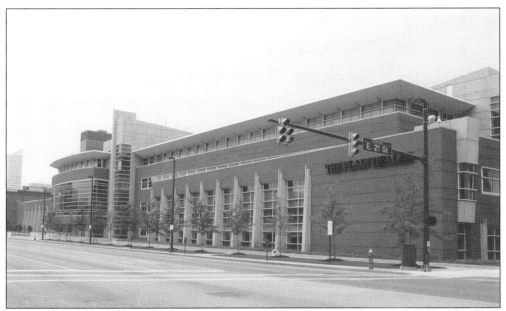

CLEVELAND PLAIN DEALER. Occupying the full length of the block at Superior Avenue and East 21st Street is this striking building, home to the *Cleveland Plain Dealer*, Cleveland's daily newspaper. The large curved glass section of the façade anchors the building's entrance and the reddish walls are sensitive to the context of surrounding buildings. The horizontal lines of the building are offset by a group of beige-toned vertical accents. Local architecture firm, Gilberti-Spittler and Associates were responsible for the innovative design.

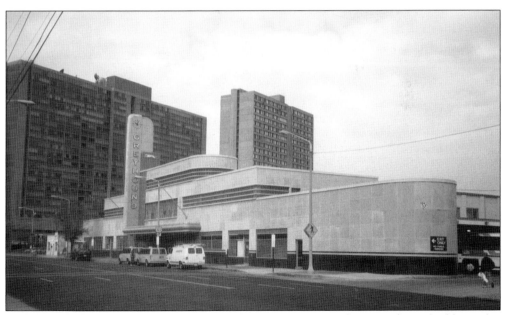

GREYHOUND BUS TERMINAL. Often cited as a quintessential art moderne building, this structure underwent a sensitive interior and exterior restoration. The lengthy façade of the building, its rounded endwalls, and the vertical signage denoting the entrance are all typical of the era when this terminal was constructed.

UTICA BUILDING. Located on East Ninth Street across from Jacobs Field, this building has a striking orange-red brick façade. The vibrantly toned brick is complemented by the darker-hued cornice.

POINTE AT GATEWAY. One of the narrowest flatiron style buildings in Cleveland, this mixed-use structure is home to Kent State University's Urban Design Center, and street level retail and restaurant space. The design center is part of a collaboration between several northeastern Ohio universities and is located on the second floor of the building.

1222 PROSPECT AVENUE. Another flatiron styled building in the Gateway neighborhood, this charming structure features bay windows on its upper floor. The rounded "point" section provides a sweeping view of the southern edge of the Playhouse Square district.

Four

STADIA, ATTRACTIONS, AND CHURCHES

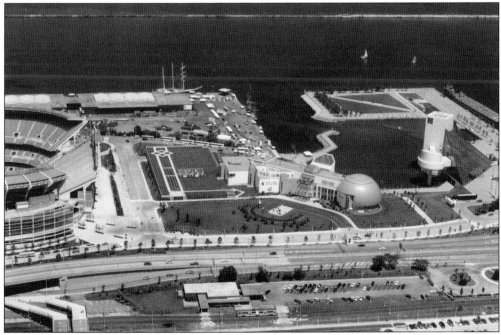

NORTH COAST HARBOR. North Coast Harbor is located north of the central business district, separated by Route 2, an east-west freeway also known as the Shoreway. At the time of publication, planners had suggested that the Shoreway be reduced to a boulevard to facilitate pedestrian access between the two areas.

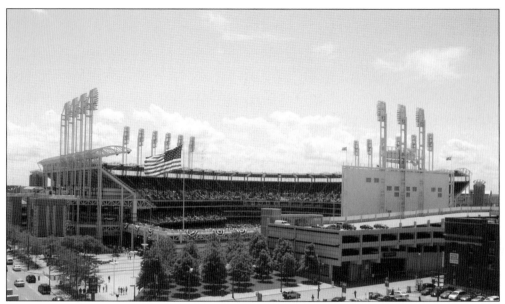

JACOBS FIELD. Cleveland's Jacobs Field is truly a landmark of the city—impressive considering its relatively short existence. In the 1990s, a massive stadium construction trend occurred in many major cities, including Cleveland. Jacobs Field (affectionately known as "the Jake") was built atop a formerly declining area in the southern edge of the central business district. The stadium, named after a former owner of the Cleveland Indians team, offers arresting views of the skyline, thanks to the innovative "cut outs" in the seating sections. The park also features a substantial amount of public art on its grounds, enhancing the visitors' experience.

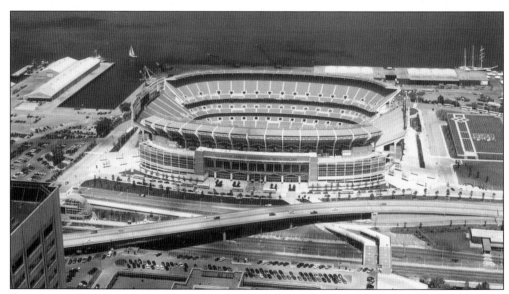

CLEVELAND BROWNS STADIUM. Due to the much-decried relocation of the Cleveland Browns football team, this massive structure was built on the site of the former Municipal Stadium. The stadium has not received accolades like its baseball counterpart. Many criticize the facility's limited usage on a lakefront location as well as the methods used to finance the project. Nevertheless, the mammoth structure has one of the largest seating capacities of any sports facility in the region.

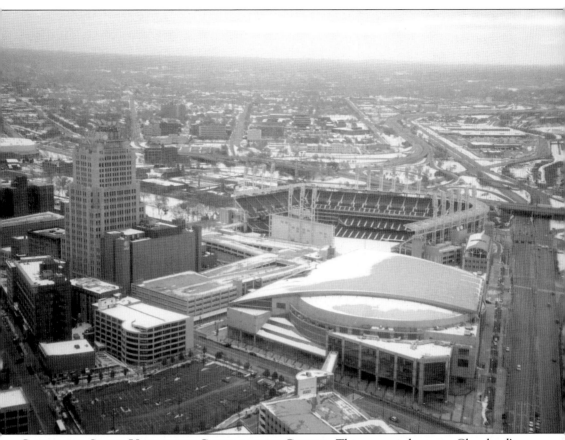

CLEVELAND STATE UNIVERSITY CONVOCATION CENTER. This arena is home to Cleveland's professional soccer team and also hosts sporting events and smaller concert performances.

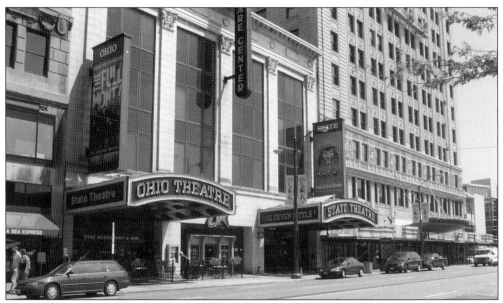

PLAYHOUSE SQUARE THEATRES. This image shows the marquees of three of the five theatres located in the Playhouse Square district. The theatre district located near Euclid Avenue at East 14th Street is truly an amazing tale of historic preservation—most of the theatres had shut down and were in various states of neglect. One person, Ray Shepherdson, started a grassroots effort in the 1970s to save the theatres from destruction. Now, the area boasts one of the largest seating counts of any theatre district in the United States, and plays host to many nationally touring companies.

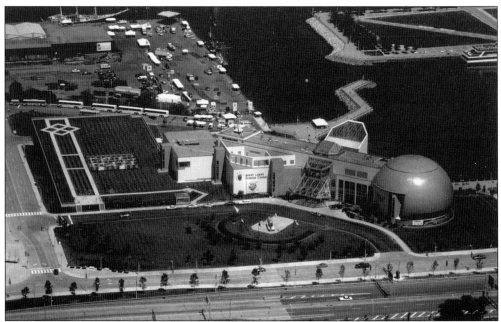

GREAT LAKES SCIENCE CENTER. One of the major components of Cleveland's North Coast Harbor, this building is a science museum featuring many interactive exhibits. The large dome on the building's eastern side is home to an IMAX theatre.

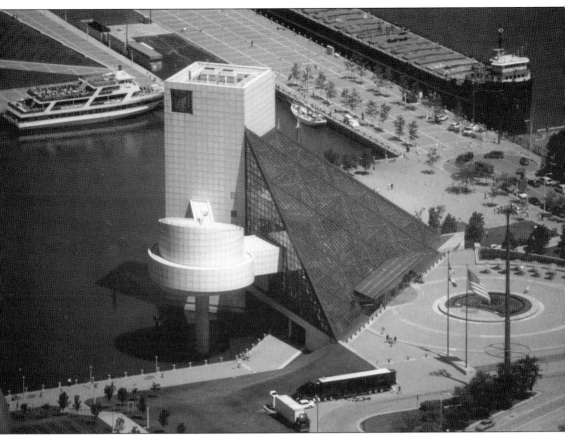

THE ROCK AND ROLL HALL OF FAME AND MUSEUM. This striking building located on Cleveland's lakefront was designed by I.M. Pei. The association of the city of Cleveland to rock music has been somewhat controversial—many cite a local disc jockey who coined the term "rock and roll." The location of the museum was also swayed by a poll, which was dominated by residents of the Cleveland area. This landmark building is home to countless artifacts of rock and popular music as well as the prestigious hall of legendary performers. The facility was originally slated to be built on the north shore of the Cuyahoga River, near the current location of the Avenue (shopping center) at Tower City Center. Eventually, the lakefront site near Voinovich Park was selected.

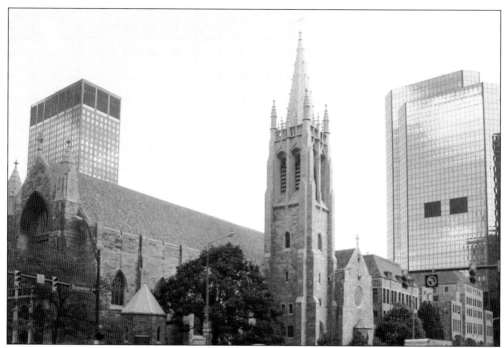

CATHEDRAL OF ST. JOHN THE EVANGELIST. This cathedral is home to the seat of the Diocese of Cleveland, which oversees most of the northeastern Ohio parishes. The current structure was built on the site of a former church and was reconfigured to accommodate other structures, including a rectory. One of Cleveland's religious landmarks, it is located at the prime intersection of East Ninth Street and Superior Avenues.

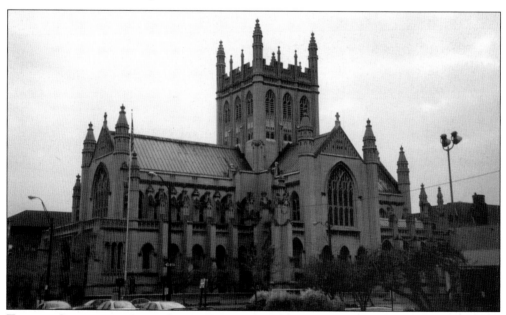

TRINITY CATHEDRAL. Located east of the central business district at East 22nd Street and Euclid Avenue, this church is often cited for its architectural and aesthetic quality. The striking structure was designed by Cleveland area architect, Charles Schweinfurth.

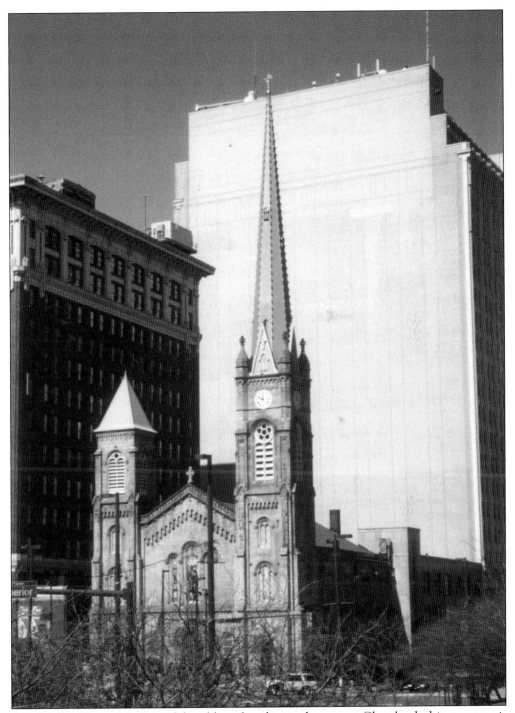

OLD STONE CHURCH. One of the oldest churches in downtown Cleveland, this structure is maintained by a Presbyterian congregation. Prior to a restoration in the 1990s, the façade was nearly black in appearance due to pollution. In addition to a thorough cleaning, the church acquired a new steeple on the southeastern tower, a much more inspired element than its western counterpart.

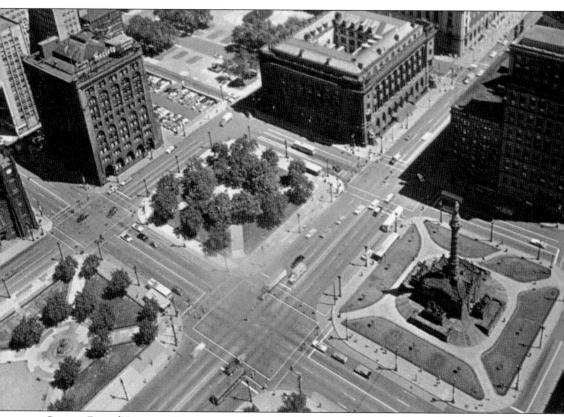

GROUP PLAN/VINTAGE POSTCARD. This view from the late 1950s shows that most buildings adjacent to Public Square were low- or mid-rise structures. By the 1990s, the area would be home to two of the tallest buildings in the state of Ohio.

Five

GROUP PLAN

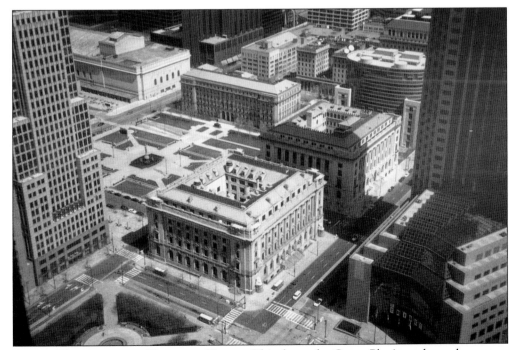

AERIAL VIEW FROM THE TERMINAL TOWER. This shows the Group Plan's southern elements as well as the flanking skyscrapers. Mall A is visible in the upper left of the photo, with the beaux-arts-styled Old Federal Building and Cleveland Public Library Main Branch in the center of the image.

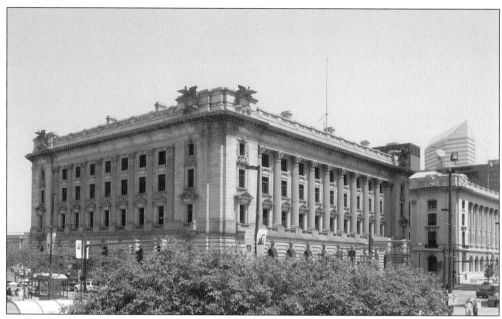

OLD FEDERAL BUILDING. This imposing structure stands at the southwestern edge of the Group Plan, adjacent to Public Square. Originally constructed as the Post Office and Customs Building, the building now serves as a courthouse for the federal government.

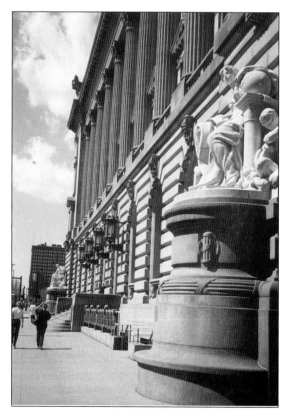

OLD FEDERAL BUILDING–DETAIL. Seated on the southern façade of the Old Federal Building are two large sculptures by Daniel Chester French, titled "Commerce" and "Jurisprudence." The two sculptures are placed above the streetscape atop.

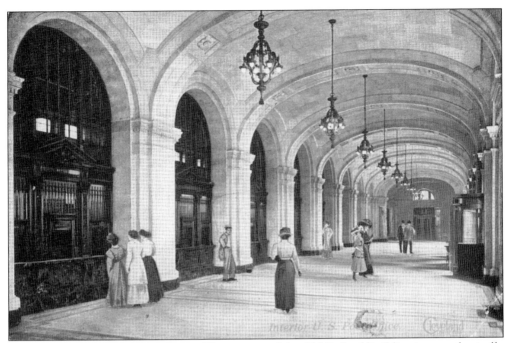

OLD FEDERAL BUILDING INTERIOR. The interior of the Old Federal Building is as aesthetically pleasing as the exterior, as viewed in this vintage image. Long corridors accented with sculpted archways add elegance to the building.

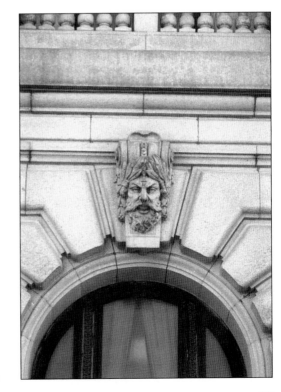

OLD FEDERAL BUILDING–EXTERIOR GARGOYLE. The exterior of the Old Federal Building is accented by a series of bearded gargoyles placed around the perimeter. The imposing nature of the structure is enhanced by the gargoyles' placement above the arched window bays.

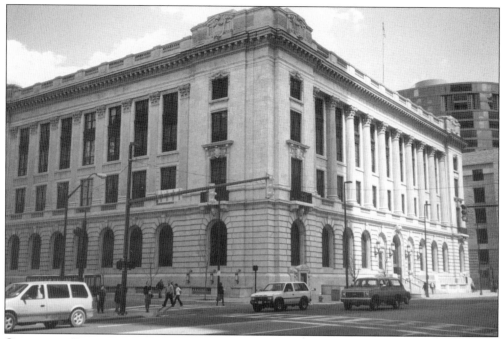

CLEVELAND PUBLIC LIBRARY–EXTERIOR. Similar in proportion to the Old Federal Building, the main branch of the Cleveland Public Library offers a more refined aesthetic with its gleaming marble façade.

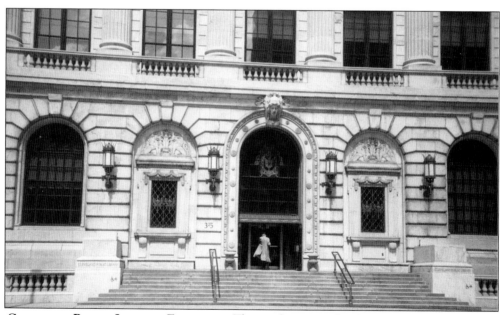

CLEVELAND PUBLIC LIBRARY–ENTRANCE. The combination of architectural elements such as the gargoyle above the entryway, the lighting standards, and the balustrades under the windows greatly enhance the visitors' experience.

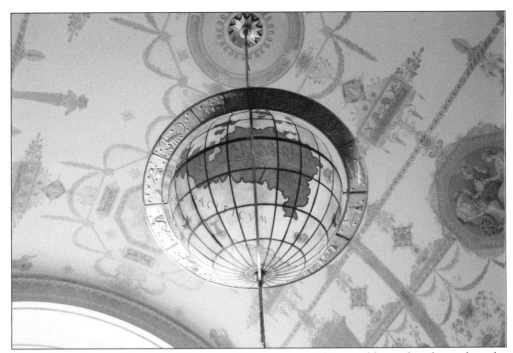

CLEVELAND PUBLIC LIBRARY–GLOBE OF KNOWLEDGE. This notable work is located in the lobby of the library's main branch and is often used as a symbol for the facility. The globe rests beneath a barrel-vaulted ceiling accented by decorative paintings.

CLEVELAND PUBLIC LIBRARY–GARGOYLE. Similar in scale to the Old Federal Building, the gargoyles of the library differ in their gender as well as the fact that their presence is limited to the corner areas.

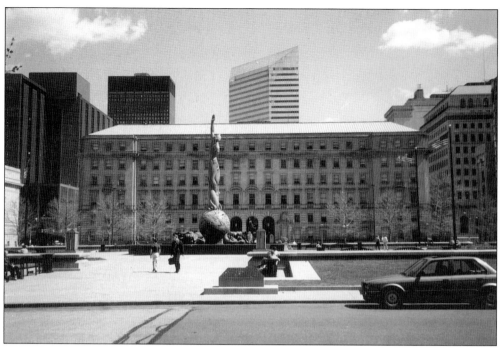

BOARD OF EDUCATION. This building is located to the east of Mall A, and features a sandstone exterior that is extensively carved as well as accented with ornamental light standards.

BOARD OF EDUCATION–DETAIL. This image shows the intricate detailed ornamentation to be found at the building's entrance near Mall A.

BOARD OF EDUCATION–LIGHT STANDARD. Located on the eastern façade of the building, this lighting standard is part of a series creating a dramatic entrance from the East Sixth Street streetscape.

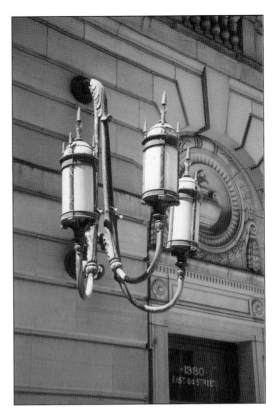

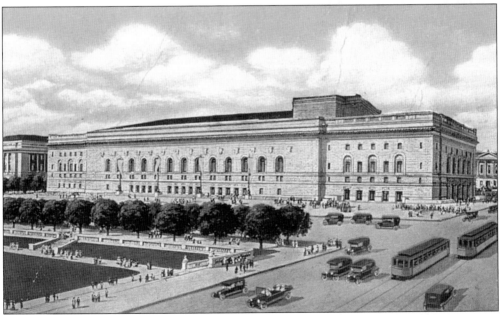

CLEVELAND PUBLIC HALL. This massive, block-long structure is home to several meeting facilities, including the Cleveland Convention Center and the well-regarded Music Hall. Also connected with this structure are the convention center facilities located underground to the west of the main building, underneath Mall B.

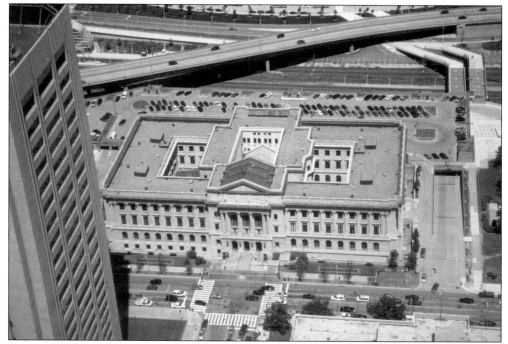

CUYAHOGA COUNTY COURTHOUSE. This view from Key Tower shows the site of the courthouse, at the northwestern corner of the Group Plan. The handsome building shares similarities in scale to the Cleveland City Hall to the east. The courthouse however, is a more ornate structure. One notable difference is the courthouse's series of columns with Corinthian capitals. The courthouse underwent a substantial reworking of its lighting, including multi-colored exterior accent lights.

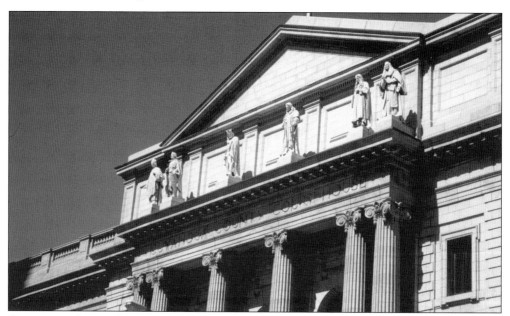

CUYAHOGA COURT COURTHOUSE. The various sculptures near the entrance of the courthouse represent various characters of literary and legal history.

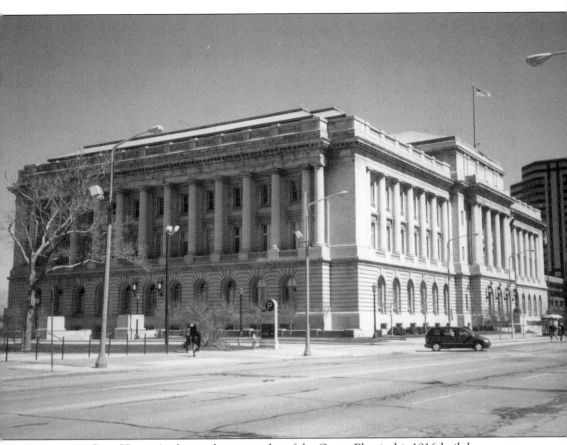

CLEVELAND CITY HALL. At the northeastern edge of the Group Plan is this 1916-built beaux-arts structure, home to the municipal government of Cleveland. The Doric-styled columns represent a stately yet restrained aesthetic, in contrast to the nearby Cuyahoga County Courthouse.

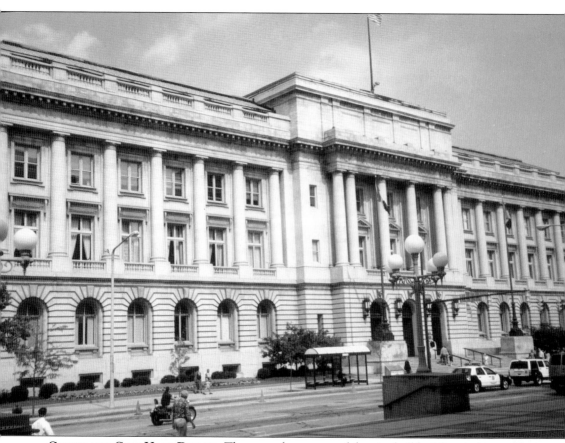

CLEVELAND CITY HALL DETAIL. The central entrance of the city hall building is denoted by a slightly projecting bay with the United States flag presented high above.

Six

WAREHOUSE DISTRICT/ FLATS

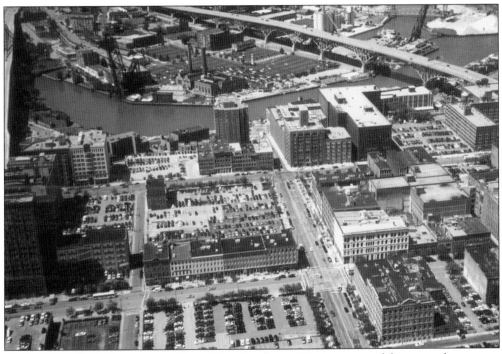

WAREHOUSE DISTRICT AERIAL VIEW. The Warehouse District is one of the most vibrant areas of downtown Cleveland. The area stretches from Superior Avenue on the south to the Shoreway on the north, and from Public Square to West Ninth Street. In recent years the Warehouse District has become one of the premiere areas in the region for entertainment and nightlife. In addition, many of the former warehouses have undergone adaptive-reuse into residential properties.

Just west of the Warehouse District along the banks of the Cuyahoga is the Flats entertainment district. Home to many restaurants and nightspots, the area's focus is transitioning from nightlife to residential use and business. However, several nightclubs still operate on the main route of the East Bank—Old River Road.

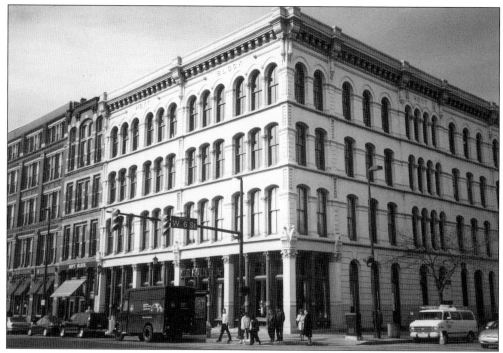

HOYT BLOCK. This former commercial building sits at the heart of the Warehouse District at West Sixth Street and St. Clair Avenue. The capitals of the columns accenting the building's base add to the structure's handsome streetscape presence.

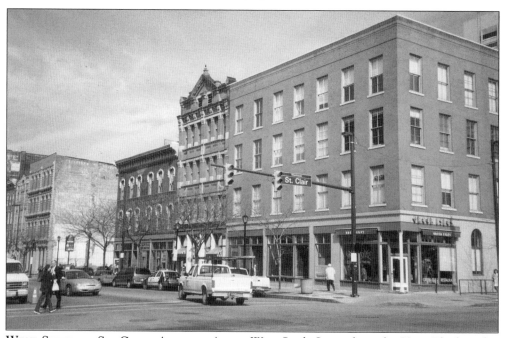

WEST SIXTH AT ST. CLAIR AVENUE. Across West Sixth Street from the Hoyt Block is this less-dramatic structure which is known as the Waring Block. It features residential units in the upper floors as well as retail space on the ground level.

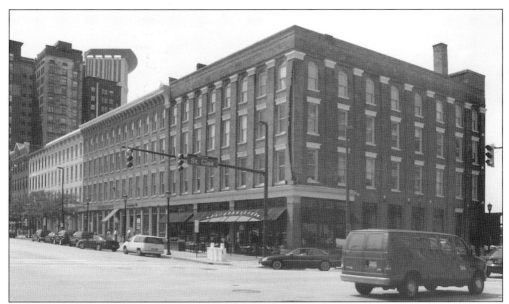

WEST SIXTH STREET–LOOKING SOUTH. This group of buildings known as the Johnson Block comprises one of the most handsome streetscapes in the Warehouse District. Anchored by the Burgess Building on the south, this block-long group of buildings is listed on the National Register of Historic Places.

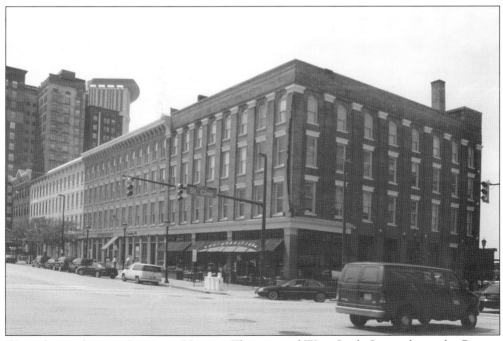

WEST SIXTH STREET–LOOKING NORTH. This view of West Sixth Street shows the Burgess Building located near Frankfort Avenue. The Burgess Building is adjacent to, but substantially taller than, the Johnson Block. Constructed in 1874, the building now serves as a commercial office building with ground-floor retail space.

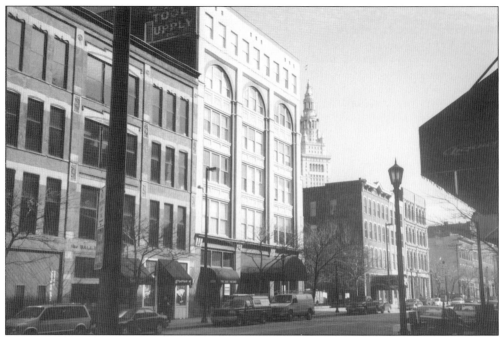

WEST SIXTH. Further north along West Sixth is the Hat Factory–one of the earliest buildings in the district to be converted to residential use. The handsome arched windows on the upper floors are made more obvious by an earlier removal of the building's cornice

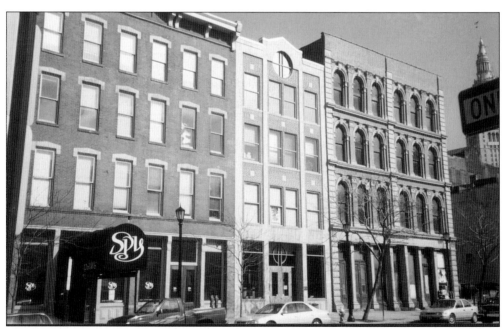

WEST SIXTH. This interesting grouping of buildings is located on West Sixth Street, north of St. Clair Avenue. The center building is a more recent construction than the two flanking buildings, but the architect chose to integrate the structure in context with the neighborhood's aesthetics.

BRADLEY BUILDING. The Bradley Building stands as a landmark of the district's northern edge with its large series of fan-topped windows. The building was constructed as the Root-McBride Building and was renamed upon its renovation.

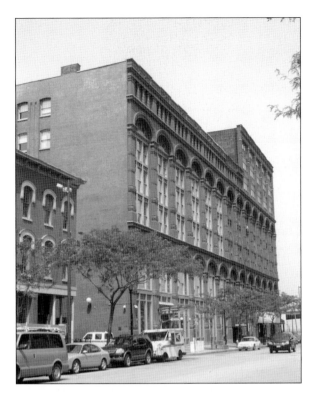

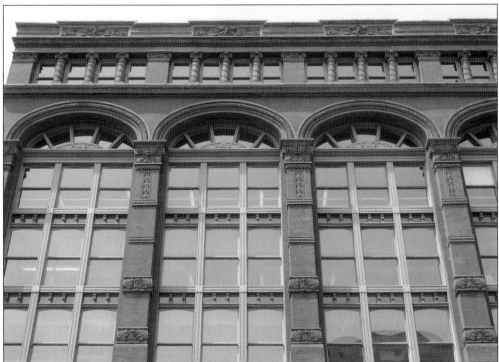

BRADLEY BUILDING DETAIL. The striking series of arched windows convey the Bradley Building's landmark status on the Warehouse District's primary north-south artery.

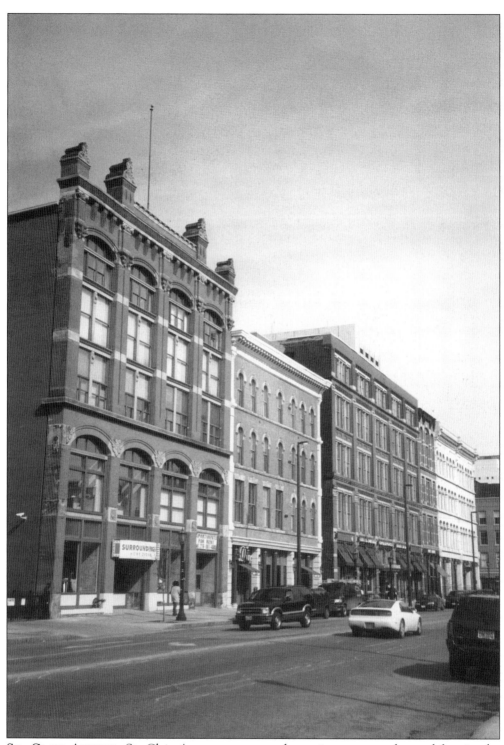

ST. CLAIR AVENUE. St. Clair Avenue serves as the main east-west thoroughfare in the Warehouse District. This handsome grouping of buildings includes the Worthington Building, seen in the foreground.

WORTHINGTON BUILDING. This attractively detailed structure was constructed for the Worthington Company, a hardware distributor. The Worthington Company is no longer in existence but this building now serves as a residential structure with retail space offered at the street level.

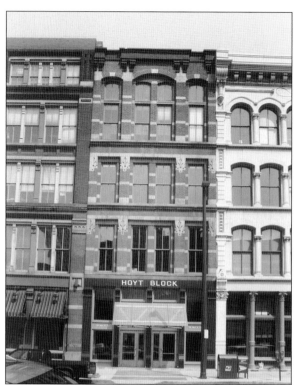

HOYT NO. 2/WEST SIXTH. Also located along the St. Clair corridor is this building that serves as the entrance to the adjacent Hoyt Block. The red masonry and sandstone accents stand in contrast to the Hoyt Block's lighter tones.

GRAND ARCADE. This building formerly housed the City Mission, a charitable organization specializing in aiding the homeless. Interestingly enough, it now serves as for-sale housing with loft-style condominiums on its upper floors.

WEST NINTH STREET. The buildings near the West Ninth Street corridor tend to be of a larger scale than other areas in the Warehouse District. The West Ninth Street buildings tend to be six to twelve stories in height and possess substantially larger "footprints." Due to the topography, several buildings have frontage on both West Ninth Street and the much lower Old River Road.

BINGHAM BUILDING. One of the largest buildings in the Warehouse District, this structure was designed by the famed Cleveland architecture firm of Walker and Weeks. The building features intriguing brickwork and a subtlety flared cornice. At the time of this publication, the Bingham Building was being converted to residential use.

NATIONAL TERMINAL APARTMENTS. This large building is one of the Warehouse District's most prominent residential structures. The Shoreway is literally several feet from this building's northern façade.

MARSHALL PLACE. At one time in terrible disrepair, this building was renovated in 2000—one of the Warehouse District's most extensive restoration projects. Locally based firm Marous Brothers handled the restoration that is now home to over forty residential units.

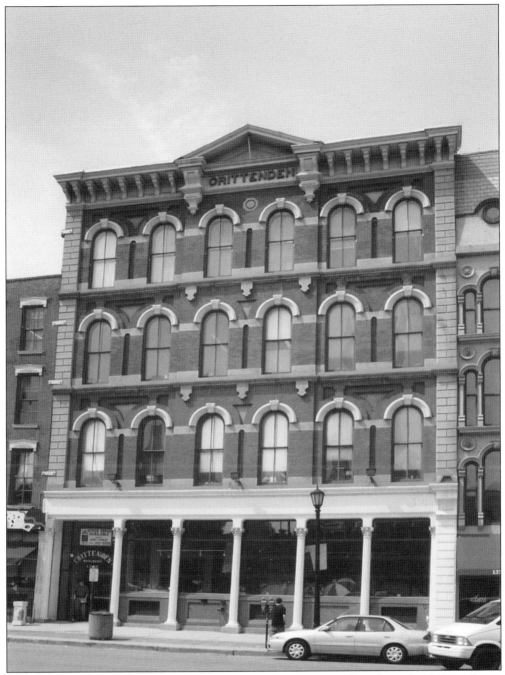

CRITTENDEN BUILDING. The Crittenden Building was renovated in the early 1990s and now serves as office space. The combination of arched window bays and the building's prominent pediment give this structure a prominence that adjacent buildings lack.

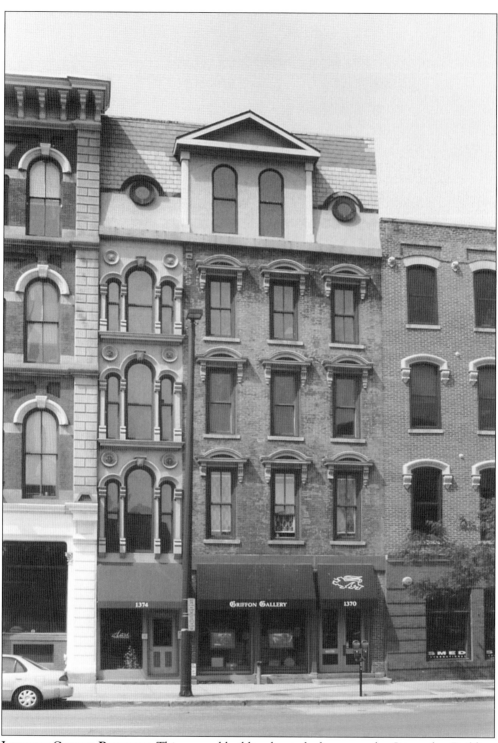

LORENZO CARTER BUILDING. This unusual building located adjacent to the Crittenden Building on West Ninth Street consists of two contrasting facades sharing a common mansard roof. The building serves as a residential structure as well as offering retail space on the ground level floor.

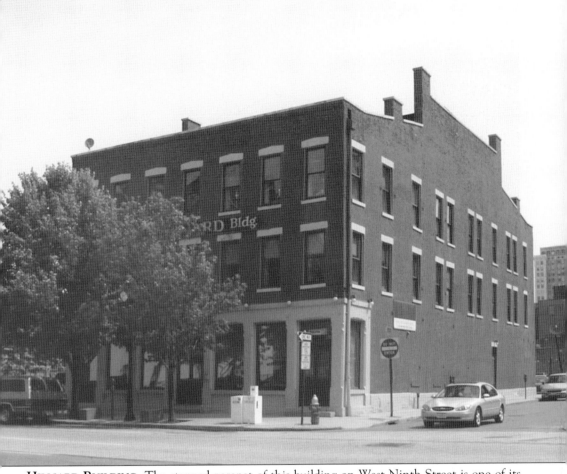

HILLIARD BUILDING. The stepped parapet of this building on West Ninth Street is one of its most notable features. As one of the oldest existing structures in the Warehouse District, the building has been remarkably well preserved and now serves as modern office space.

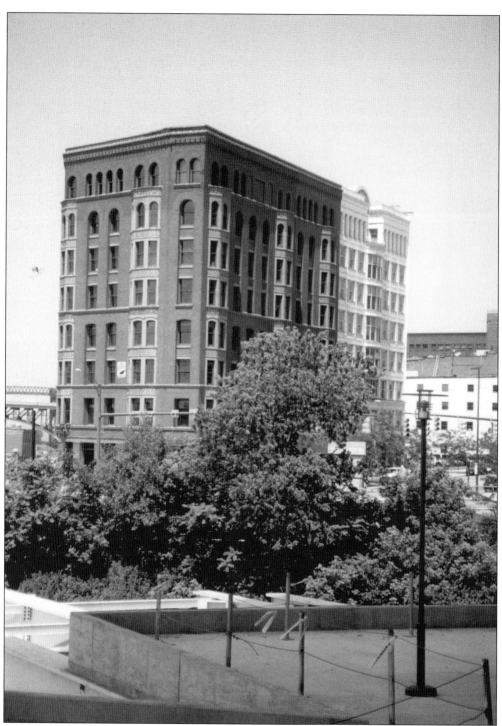

WESTERN RESERVE BUILDING. This landmark building located at the southwestern edge of the Warehouse District was designed by noted architect Daniel Burnham. The Chicago-style windows and irregular site plan add to this building's interest. An addition was constructed in 1990, adding floor space in a contrasting yet attractive style.

PERRY-PAYNE BUILDING. Located at the southern edge of the Warehouse District on Superior Avenue, this handsome structure was constructed in 1888 as an office building. Over time, it had become neglected, with many of the windows bricked in and the façade in need of restoration. Fortunately a renovation in the mid-1990s brought the building back to its full glory, which now serves as a mixed-use structure.

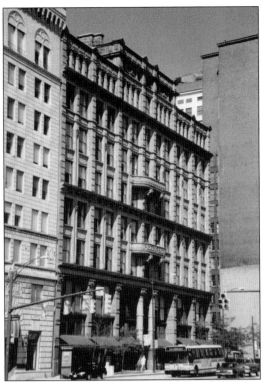

BERTSCH BUILDING. This small office building on the eastern edge of the Warehouse District is an eclectic study in Tudoresque styles.

L.H. Gross Building. Located at West Third Street and Lakeside Avenue, this impressive structure boasts substantial windows as well as proximity to the Cuyahoga County Courthouse and Justice Center.

The Marion Building. Occupying a narrow lot on West Third Street, this building is home to many legal firms—appropriate considering the building's proximity to the municipal court buildings.

COURTHOUSE SQUARE. A landmark of the northern edge of the Warehouse District, this building is located at the West Third Street and Lakeside Avenue intersection. The building's brick exterior combined with the contrasting terra-cotta cornice creates a dramatic effect.

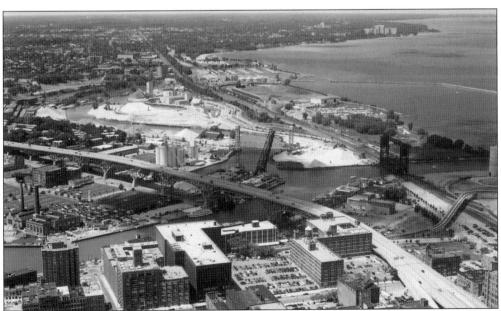

NORTHWEST WAREHOUSE DISTRICT/FLATS/CUYAHOGA AERIAL. This view from Key Tower shows the mouth of the Cuyahoga River and the Flats district. The Flats was Cleveland's most vibrant nightlife district for many years; however, in recent years its popularity has waned. One notable feature about the East Bank of the Flats—it is directly served by the city's light-rail transit line.

OLD RIVER ROAD. Old River Road serves as the primary north-south artery on the East Bank of the Flats. Many of the structures seen here were constructed to house companies serving the shipping and manufacturing industries. Most have been converted into use as restaurants and nightspots.

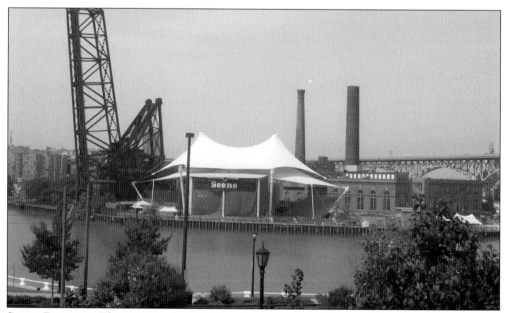

SCENE PAVILION. The West Bank of the Flats features some of the most dynamic structures along the Cuyahoga River. In this image, one of the famed bridges stands locked in upright permanent position. The large canopied structure was built as the Nautica Stage, a large amphitheater and is now known as the Scene Pavilion—named after a weekly alternative newspaper.

Seven

INTERIORS

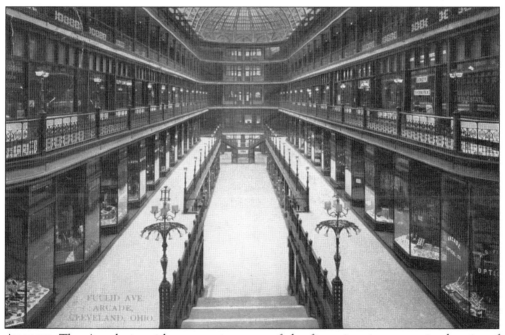

ARCADE. The Arcade is, without question, one of the finest interior spaces in the city of Cleveland. The building is composed of two nine-story towers—one facing Superior Avenue, the other facing Euclid Avenue—connected by a 300-foot long, five-level public atrium. The Arcade was the first in Cleveland to be listed on the National Register of Historic Places and was also one of the first of ten structures in the United States to be given that honor. Investors in the building's construction included some of Cleveland's most famous industrialists, including the world's first billionaire, John D. Rockefeller, chairman of Standard Oil.

A little known fact is that the Arcade's current interior is not as it was originally constructed. A "modernization" of the building resulted in several dramatic changes. The Superior Avenue staircase originally was a "Y"-shaped structure, which was replaced with the "grand staircase" which houses a small retail space at its base and is accented with Art-Deco motifs. Another significant change was the interior lighting standards, which are more restrained than their predecessors .

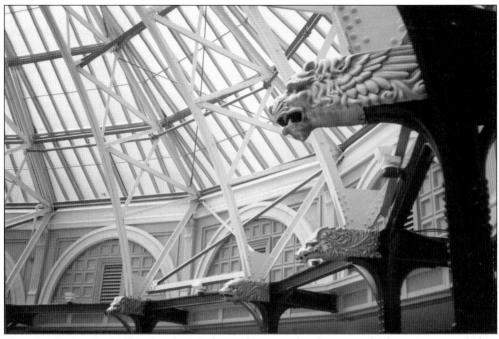

ARCADE GARGOYLES. This detail view shows the gargoyles that encircle the atrium, just below the massive skylight. The gargoyles take the stylized forms of various mythical beasts.

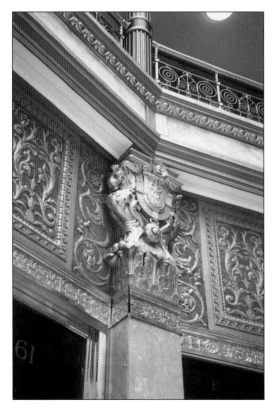

ARCADE COLUMN. The extent of detail is readily seen in this column, one of the many columns seen on the second level of the structure. The building cost $875,000 to construct in 1890—it would be nearly impossible to recreate this architectural masterpiece.

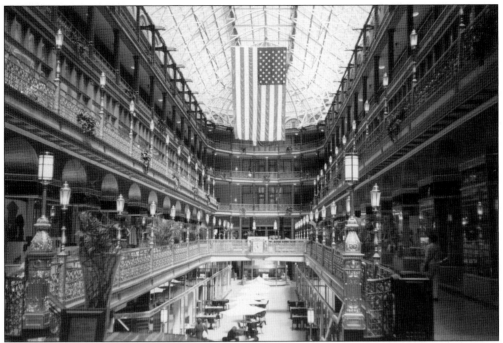

ARCADE/MAIN VIEW. This view of the atrium area shows the multiple levels of the Arcade and the series of lighting standards that create a unique sense of ambiance in downtown Cleveland.

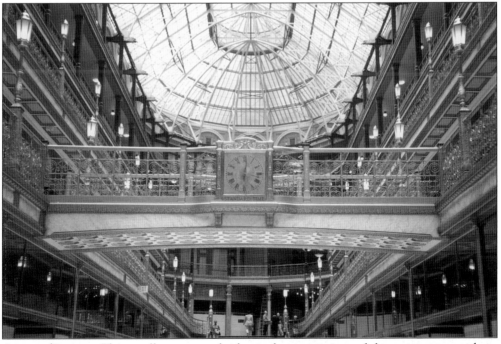

ARCADE/BRIDGE. This small connector bridge is the centerpiece of the atrium area with its prominent clock. Even the underside of this bridge is given lavish decorative treatment, further testament to the Victorian aesthetic.

DETAIL/GRILLWORK. This decorative grillwork is seen on the Arcade's staircase near Superior Avenue. The art-deco influence reveals that it is not part of the buildings original construction in 1890.

ARCADE SKYLIGHT. The massive skylight that fills the Arcade's atrium with natural light is seen in this image. During the Arcade's restoration, the skylight was replaced with exceptional sensitivity to the building's historical context.

COLONIAL ARCADE. Located in the Colonial Marketplace complex, this attractive space is home to retail space on the lower floor, with the upper floors serving as hotel space. The Colonial Arcade stretches from Prospect Avenue north to Euclid Avenue. The upper level balcony and skylight add to the space's appeal.

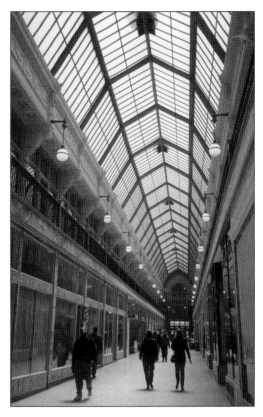

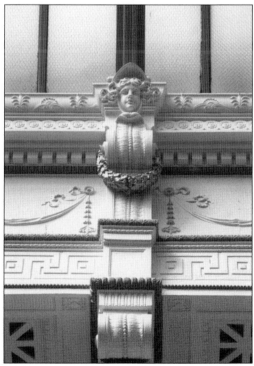

COLONIAL ARCADE DETAIL. The upper balcony of the Colonial Arcade features a series of unique lighting standards. Other notable decorative elements include this cherub-like feature that caps the lighting standard brackets.

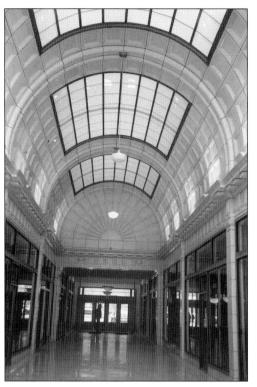

EUCLID ARCADE. A more restrained pedestrian space than other arcades in Cleveland, the Euclid Arcade features a barrel-vaulted ceiling with attractive terra cotta appointed walls and marble flooring. The Euclid Arcade runs parallel to the Colonial Arcade and is connected to its more ornate counterpart via a pedestrian corridor. The Euclid Arcade is home to several fine art galleries and studios.

TERMINAL TOWER PORTICO. Often overlooked for the expansive retail space in the Tower City Complex, this attractive area is at the base of the Terminal Tower. The exquisitely detailed ceiling and large windows facing Public Square create a dramatic space suitable for Cleveland's landmark skyscraper.

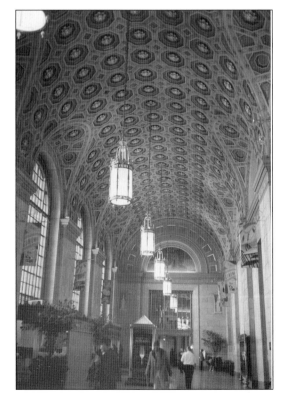

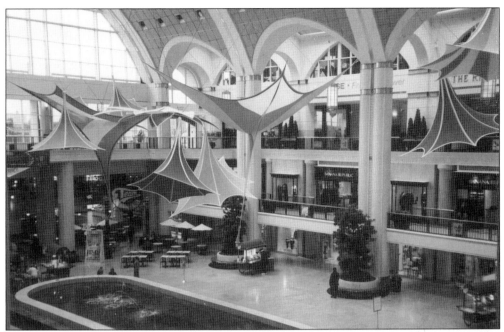

The Avenue at Tower City. The retail component of the Tower City Center project in the early 1990s included this dramatic atrium featuring massive barrel-vaulted skylights and a variety of fountains.

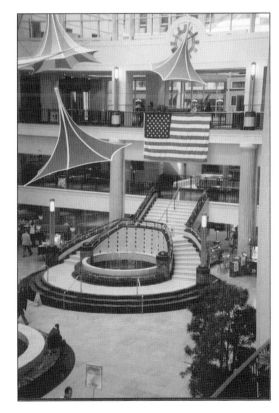

Avenue/Staircase. This grand staircase serves as a focal point for the main concourse of the shopping center.

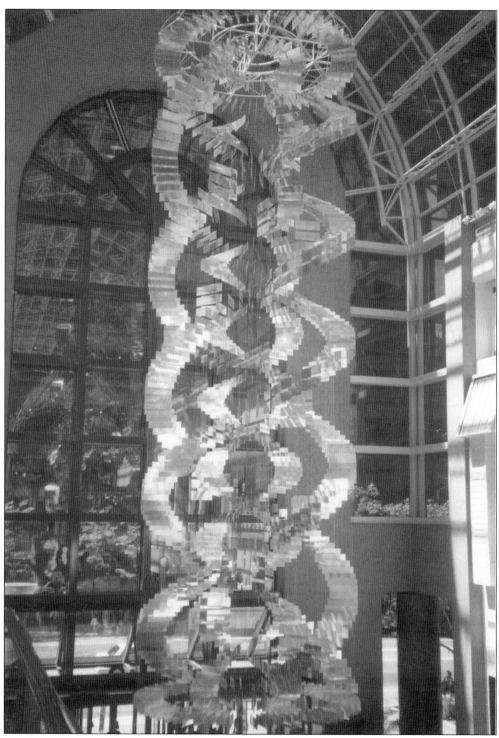

SCULPTURE AT GALLERIA. This dazzling work is displayed near the East Ninth Street entrance to the Galleria. Created by artist William Whitman, it is composed of holographic glass panels that reflect and shimmer in a rainbow of color.

OVERHEAD OF GALLERIA. Built in 1987, the Galleria shopping center was built atop the plaza that fronted the Tower at Erieview. The dramatic space is decidedly post-modern. Seen in this view from the Penton Media Building, the Galleria's signature barrel-vaulted glass ceiling provide abundant natural light to tenants and guests. At the time of this publication, the Galleria was slated for an extensive cosmetic overhaul.

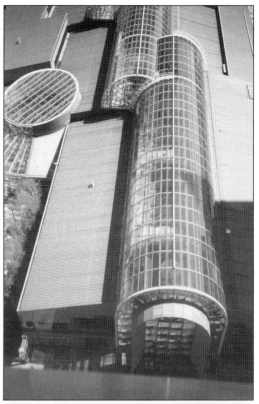

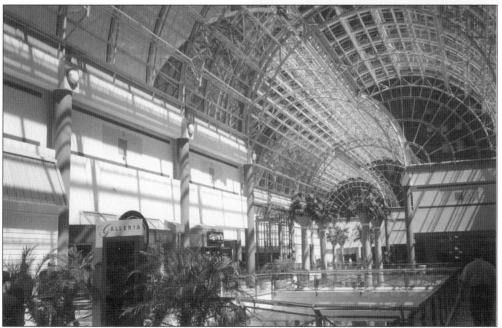

GALLERIA INTERIOR. The Galleria's barrel-vaulted ceiling creates a dramatic effect in the shopping center's interior. The ceiling is composed of three sections, each slightly staggered along the axis of the shopping center.

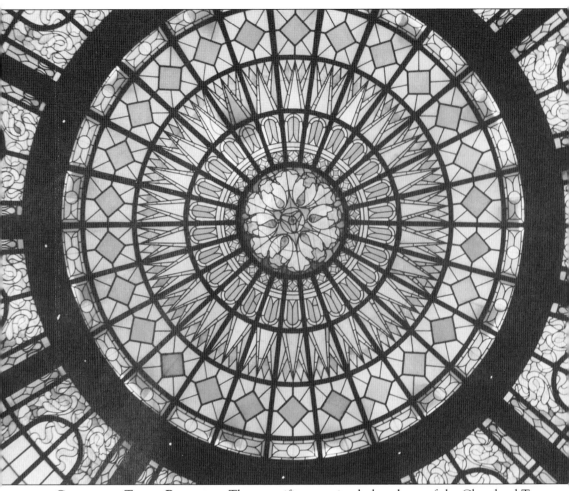

CLEVELAND TRUST ROTUNDA. The magnificent stained-glass dome of the Cleveland Trust building's rotunda is seen here. The 1905-built structure was one of the leading banks in Cleveland for many years. The rotunda and adjacent tower were closed in the early 1990s due to a series of bank mergers.

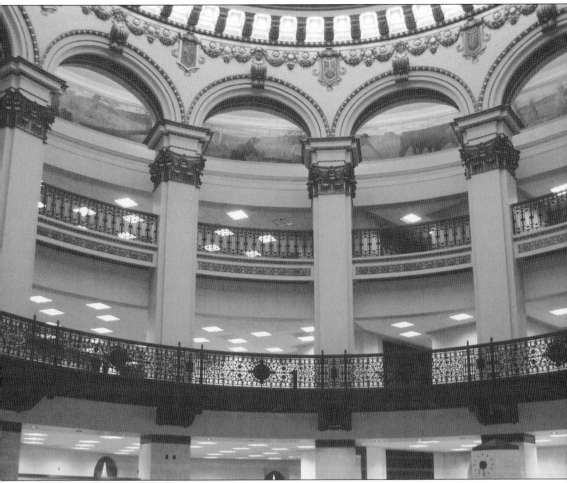

CLEVELAND TRUST/ROTUNDA 2. The mezzanine levels of the Cleveland Trust rotunda are as exquisitely decorated as the domed ceiling. Visible in the upper portion of this image are murals painted by Francis Millet, a noted painter who passed away at sea when the Titanic sank in 1912. The lower portion of the image shows the intricate railings of the lower mezzanine levels.

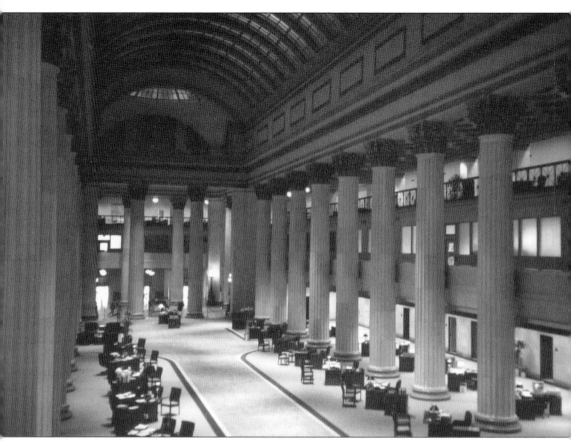

HUNTINGTON BUILDING LOBBY. Constructed in 1924, this massive space remains of the largest banking halls in the world. The "L"-shaped lobby is anchored by a large domed skylight (artificially lit).

Eight

PUBLIC ART/SCULPTURE

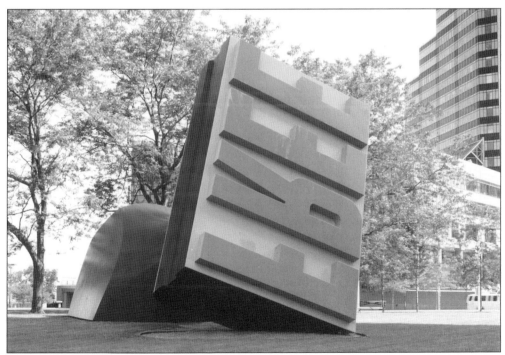

FREE STAMP. One of the most controversial pieces of public art in the city of Cleveland, this was originally planned for a Public Square site. After time, the piece was placed in Willard Park, just east of Cleveland City Hall. Claes Oldenburg designed this notable sculpture and has important pieces in many North American cities.

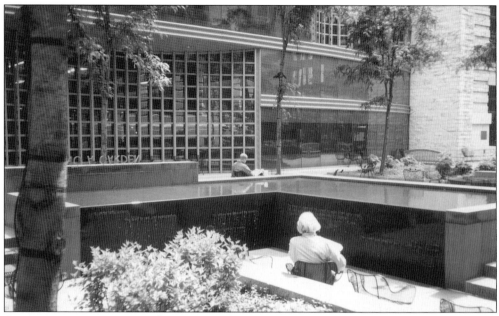

CLEVELAND PUBLIC LIBRARY/MAYA LIN. The Eastman Garden at the Cleveland Public Library was completed with the construction of the Louis Stokes Wing. The centerpiece of the garden is a fountain by noted artist Maya Lin, titled "Reading a Garden." Maya Lin also designed the Vietnam Veterans Memorial in Washington, D.C.

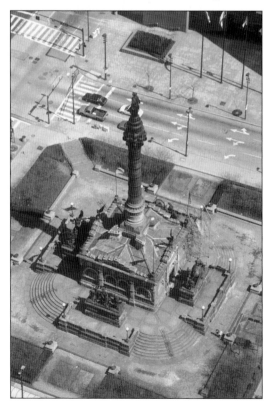

SOLDIERS AND SAILORS MONUMENT. Constructed in 1894 on the southeastern quadrant of Public Square, this monument honors Cleveland area residents who served in the Civil War. The monument, designed by Levi Scofield, stands 125 feet tall, and is topped with a statue representing liberty.

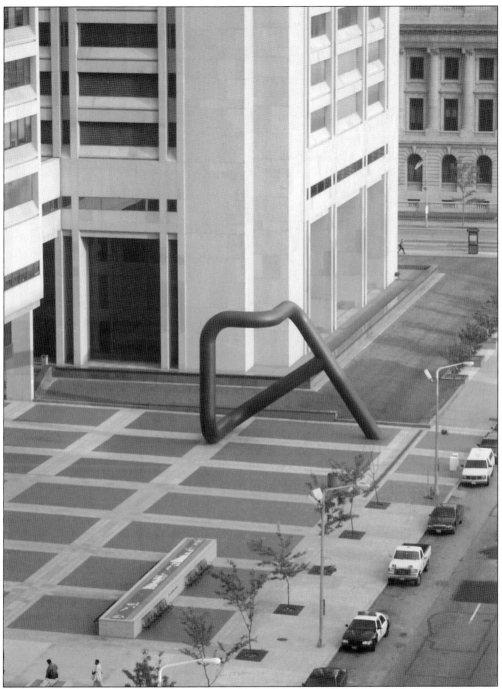

PORTAL/NOGUCHI. Constructed of steel pipe, this work by famed artist Isamu Noguchi is considered among his best, although it is not as well known as works in other North American cities. Located at the Justice Center's eastern plaza, the imposing piece takes on different forms as the viewer moves around it.

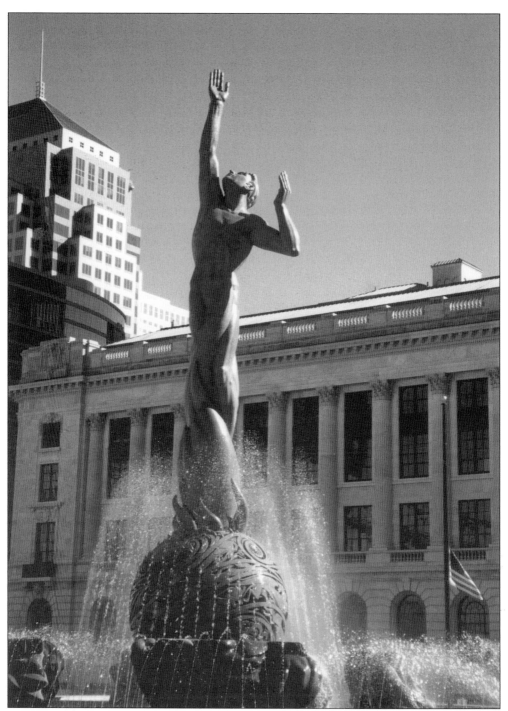

WAR MEMORIAL FOUNTAIN. This notable work by Marshall Fredericks is the centerpiece of Mall A, the southernmost area of the Group Plan. In 1991, the area underneath the Mall A was converted into an underground parking garage and the fountain placed atop the parking structure. The sculpture represents mankind rising above various tribulations and is often used appropriately as a symbol of the city.